IMAGES
of America

VININGS

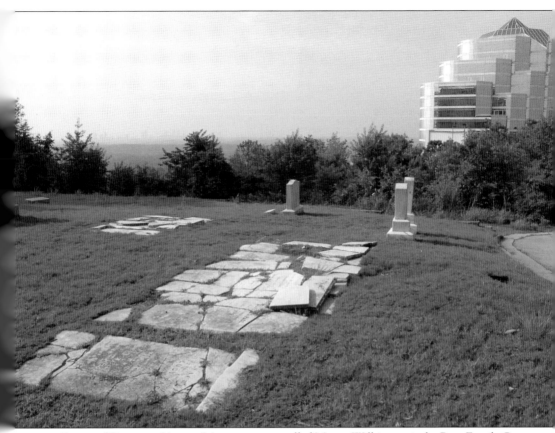

On top of Crowning Vinings Mountain, now called Mount Wilkinson, is the Pace Family Cemetery. Several of these old grave markers pre-date the Civil War and have either deteriorated or have been vandalized over time. They stand in contrast to the modern office buildings and condominiums that surround them. The early settlers' graves still watch over the city of Atlanta, juxtaposing the old and new of this community. (Courtesy of Ross Henderson Photography.)

ON THE COVER: Teasley Elementary School opened in 1963 to serve the Vinings community along with other communities in southeast Cobb County. The school opened as a facility for grades one through eight. Mrs. Doyle had one of the two first-grade classes that opening day. (Courtesy of Teasley Elementary School.)

IMAGES
of America

VININGS

Susan Kendall

ARCADIA
PUBLISHING

Published by Arcadia Publishing
Charleston, South Carolina

Printed in the United States of America

Library of Congress Control Number: 2012949017

For all general information, please contact Arcadia Publishing:
Telephone 843-853-2070
Fax 843-853-0044
E-mail sales@arcadiapublishing.com
For customer service and orders:
Toll-Free 1-888-313-2665

Visit us on the Internet at www.arcadiapublishing.com

The book is dedicated to my family—husband Steve, Kimberly Kendall, and Kristen and Jeremy Allegood—for all of their encouragement and sound advice.

CONTENTS

ACKNOWLEDGMENTS

I would like to extend special gratitude to Jody Smith, along with Robert and Peggy Ahlstrand, for their support, ideas, and collection of photographs, clippings, and personal knowledge of Vinings. Special thanks go to my husband, Steve, for his extraordinary support and understanding.

My thanks for images, time, and stories extends to the Vinings Historical Preservation Society and Gillian Greer; the Smyrna Historical Society and Museum, especially Harold Smith and Kara Hunter-Oden; the Vinings Village Woman's Club and Joanne Newman; the River Line Historic Area Organization and Roberta Cook; the Bert Adams Boys website and Thomas Watson; the Vinings Jubilee and Eva Bass; Ross Henderson Photography; Jen Case, photographer; the Log Cabin Church and Mariah Thompson; the Vinings United Methodist Church and Nancy Krauth; Teasley Elementary School; Mike Stoudemire, director of the Kennesaw Mountain Historical Association; Michael Conley; Janet Dickerson; Ann Konigsmark Johnson; Dick Lambert; Jim Callahan; Sarah Mitchell; Mandy Ford Bubel; Mrs. Karen Cole Turner; Dolph and Judy Orthwein; Mr. and Mrs. Walter Butler; and Walter North.

INTRODUCTION

Vinings is a community; it has never been incorporated. Yet it is one of those places people familiar with the Atlanta area know. Vinings today is a part of Atlanta's Platinum Triangle of businesses. This community is known for upscale shopping and dining. A pedestrian-friendly village, it is where residents and visitors alike enjoy outdoor cafés and neighborhood boutiques. It is a community of sidewalks, shady trees, and strong civic pride.

The history of Vinings starts with Indian towns and moves on to a pioneer settlement with Hardy Pace's ferry and the coming of the Western & Atlantic Railroad. This community was then simply called Crossroads. One of the railroad's civil engineers lent his name to the station, and the small community became known as Vinings Station.

The proximity of Vinings to the river crossing into Atlanta was important during the Civil War. Vinings Mountain was the highest point along the Chattahoochee River, so Gen. William T. Sherman and his Union army took advantage of the hill first to view Atlanta and then as a signal station. The mountain became a spot for Union artillery bombardments, while the rail station area and settlement became a supply depot, hospital, and Union army headquarters. Confederate general Joseph Johnston included Vinings as a part of his River Line Defense, where he built forts and "shoupades."

The natural beauty of Vinings, with its river and rising banks, served to attract picnickers from Atlanta and summer residents who were looking for relief from the heat and congestion of the city. After all, Vinings was just a train trip, and later a trolley ride, away. The community grew with churches, stores, a country club, and social clubs to serve summer residents and the growing permanent population. There was an African American community living on Vinings Mountain; the women helped domestically, and the men worked on the railroad and labored for the more prosperous community residents.

Hardy Pace's descendants remained in the Vinings area, who are now the Carters, Randalls, McAfees, and Yarbroughs. They cared for the community and preserved the historic buildings that remain in the village. Their land gave way to the Vinings Jubilee and many commercial and housing developments.

Vinings, like other communities, had churches to serve the residents. Some of these institutions date to the early 19th and 20th centuries, and some have been discontinued with the real estate development of the area. The black churches of First and Second St. John's, Mount Sinai, and New Salem all were discontinued, with only cemeteries remaining. The old Vinings Baptist Church building now houses two restaurants. As Vinings changed, so did its community stalwarts. The contrast between old and new can be seen at the top of Vinings Mountain, now Mount Wilkinson. The very old grave markers from the 19th and 20th centuries are bordered by high-rise buildings as they overlook downtown Atlanta.

One of Vinings's long-standing institutions, remembered by men throughout the Atlanta area and beyond, is Camp Bert Adams, which was on the top of the mountain. This rugged, natural

area started as Atlanta's first permanent Boy Scout camp and continued into the 1960s. Boys fondly remember it as a troop experience requiring a train or bus ride. It is where young men got a chance to use bows and arrows as well as air guns. They learned to canoe and swim in what was then a remote area while being only a few miles from downtown Atlanta.

Several remarkable people have called Vinings home. Nellie Mae Rowe became a well-known folk artist; however, before she received the acclamation she deserved, she was the eccentric lady with the junk in her yard who created dolls and chewing-gum art. The Carter sisters, Earle Carter Smith and Ruth Vanneman, owned a considerable amount of Vinings, including the Vinings Pavilion. While Earle worked with the Cobb Commission to help direct Vinings's growth, her sister Ruth became a well-known local character who is still the subject of many stories. She was featured in a 1988 *National Geographic* article sitting on her front porch in a rocking chair, wearing her mink coat, and waxing on about Vinings and its development.

Around mid-century, Vinings started to take on more of a traditional suburban look. Dads got on the interstate to drive to work in Atlanta, and moms were involved in civic and women's clubs. The kids went to Teasley Elementary School, and often there was a neighborhood pony. The Chattahoochee River was a fun place to picnic and to float down during hot summer days. The local rock-and-roll radio station started hosting river raft races, which brought out the creativity of many of Atlanta's high school and college students. There was even a snowless ski slope that operated year-round. AstroTurf and white polyester pellets were used to get ready for a ski trip or offer an environment to learn what skiing was like, or kids could just enjoy the ski-lodge burgers like those featured at cold-weather ski slopes.

Vinings is set apart from other suburban Atlanta neighborhoods by its tradition of civic involvement. The Vinings Homeowners Association, the Vinings Civic Club, the Vinings Historic Preservation Society, the Vinings Woman's Club, and the Vinings Rotary Club all raise money for community improvement and historic preservation. They can point to years of involvement in such activities as village beautification projects, supporting historic preservation, and school improvement.

Vinings is a community with a strong sense of identity. It is common to find all of the neighborhood organizations working together on projects for preservation and beautification as well as delightful fundraising endeavors such as the golf tournament or the downhill five-kilometer run. Current residents are generous with their time and talents, making Vinings the community it is today and ensuring that it will remain a jewel in the Platinum Triangle of Atlanta.

One

PIONEERS

By the time Andrew Jackson was president, Georgia's boundaries had been drawn, but only the east and south were open for settlement. The land north of the Chattahoochee was Cherokee territory. In 1831, the Cherokee land was surveyed, and in 1832 Cobb County was formed, including what would be Vinings. Land lotteries were held for land purchases, with a separate lottery for each county. There were two types of land lottery: the gold lottery provided 40 acres, and agricultural land lots were 160 acres. Men could enter more than one lottery, and after it was complete land was often traded or sold.

The pioneer Hardy Pace owned large tracts of land from Buckhead to Smyrna, which was traded, sold, or owned by family members. The Pace land included a gristmill, ferry, tavern, farm, and perhaps a post office in an area some called Crossroads or Paces Mountain.

Nancy Still's story represents the removal of the Cherokees from the area. Georgia passed the Indian Removal Act of 1832, which said that any Native Americans found on land won in the lottery could be removed. Nancy Still's family were Cherokee farmers with cleared, improved land. The family was moved from the Vinings area to Etowah near Canton, Georgia. Although the US Supreme Court held that Indian land could not be taken, Georgia ignored the court's position. Still and the other Native Americans were then taken to Ross Landing near Chattanooga, where they and 16,000 other Cherokee Indians began the 1,200-mile journey known as the Trail of Tears to Oklahoma.

Around the same time, the Georgia Legislature approved the construction of the Western & Atlantic Railroad between what would become Atlanta and Chattanooga, Tennessee, which began in 1836. A station was established near the Chattahoochee River crossing and became known as Vinings Station, named after railroad civil engineer William H. Vinings of Delaware, designer of the railroad's trestle bridge at Stillhouse Creek.

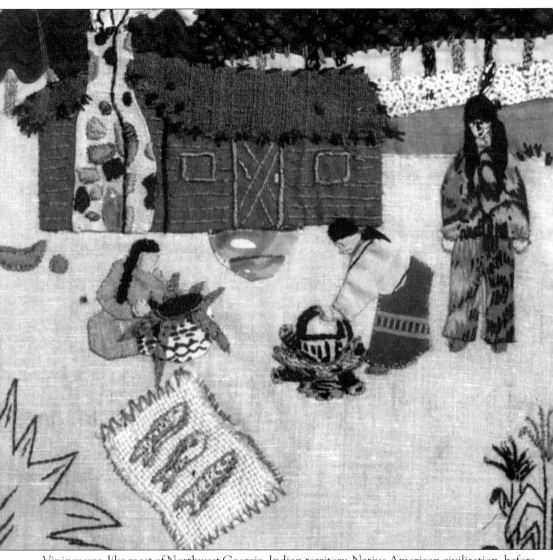

Vinings was, like most of Northwest Georgia, Indian territory. Native American civilization, before white settlement, was found in villages on both sides of the Chattahoochee River. The women farmed, and the men hunted and traded. The Vinings Quilt, a hand-stitched representation of local Vinings history, has as its first quilt square this representation of Cherokee village life along the Chattahoochee River. (Courtesy of Robert and Peggy Ahlstrand.)

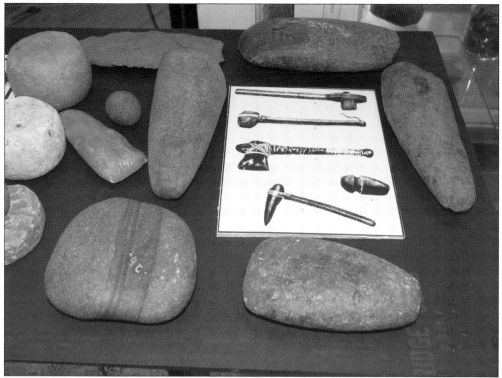

Indian artifacts are found in the Vinings community and elsewhere along the Chattahoochee River. These stones and rocks are examples of Cherokee tools and weapons used before trade with the European settlers. The shards are from pottery made from river clay and were used as a part of everyday Indian life. (Both courtesy of the Smyrna Historical Society.)

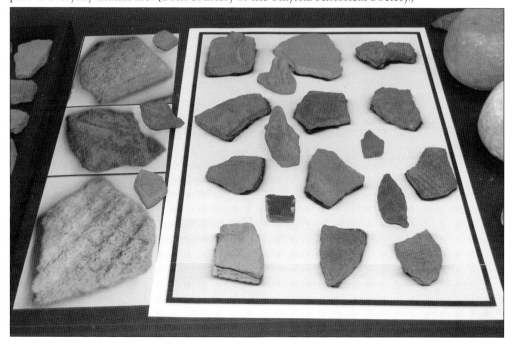

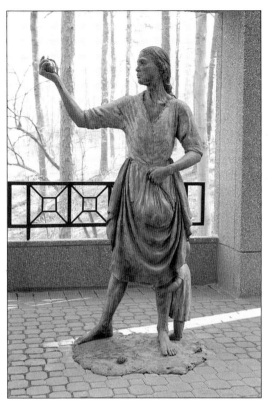

Nancy Still, a Cherokee, represents the plight of Native Americans in the early 19th century. In Cherokee culture, farming was done by women and children. Still, believed to be a widow living along Soap Creek, held a farm that she and her children had improved. She appealed to Georgia governor Wilson Lumpkin to let her keep the land to which she was rightfully entitled. Her plea was recorded: "My little children has made all the improvements with thare hand. . . . If we are turned out my children will perish." The plea was lost, and Still's family was moved north to Etowah, then farther north to Chattanooga, and then finally forced to march to Oklahoma along what became known as the Trail of Tears. There is no account of her ever reaching Oklahoma Territory. The statue of Nancy Still holding a gilded peach was made by Hilarie Johnston in 1991 and stands in the lower courtyard at Paces West Office Complex on Paces Ferry. (Both courtesy of Ross Henderson Photography.)

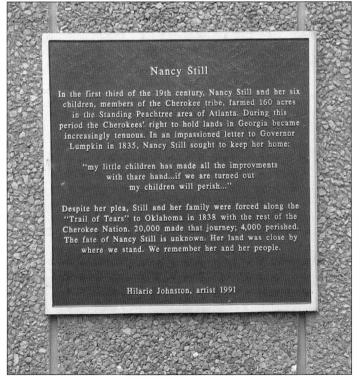

Nancy Still

In the first third of the 19th century, Nancy Still and her six children, members of the Cherokee tribe, farmed 160 acres in the Standing Peachtree area of Atlanta. During this period the Cherokees' right to hold lands in Georgia became increasingly tenuous. In an impassioned letter to Governor Lumpkin in 1835, Nancy Still sought to keep her home:

"my little children has made all the improvments
with thare hand...if we are turned out
my children will perish..."

Despite her plea, Still and her family were forced along the "Trail of Tears" to Oklahoma in 1838 with the rest of the Cherokee Nation. 20,000 made that journey; 4,000 perished. The fate of Nancy Still is unknown. Her land was close by where we stand. We remember her and her people.

Hilarie Johnston, artist 1991

Hardy Pace was a southern frontier entrepreneur. He came to Georgia from North Carolina and lived at several different places in the state. He participated in the land lotteries along with his family. Through speculation, trade, and purchase, he concentrated on accumulating land along the Chattahoochee. This was an area where, according to Anthony Doyle, the Cherokees had already established Harris Ferry and a trading post. Pace bought or acquired the ferry and the land, upon which he established a tavern, post office, gristmill, and plantation. He lived in the area with his large family. There is some question about whether he built a 17-room house or if the house and outbuildings totaled 17 rooms. According to the 1850 census, he did own 23 slaves. His statue is also by Hilarie Johnston and is inside the atrium of the Paces West Office Complex. (Both courtesy of Ross Henderson Photography.)

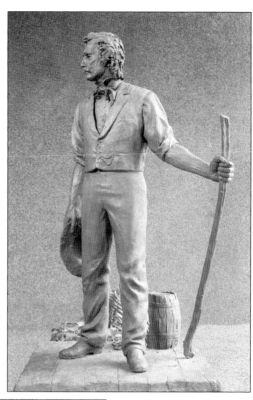

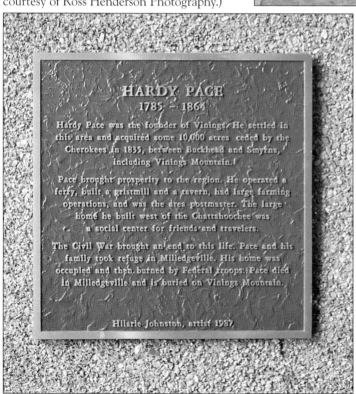

HARDY PACE
1785 – 1864

Hardy Pace was the founder of Vinings. He settled in this area and acquired some 10,000 acres ceded by the Cherokees in 1835, between Buckhead and Smyrna, including Vinings Mountain.

Pace brought prosperity to the region. He operated a ferry, built a gristmill and a tavern, had large farming operations, and was the area postmaster. The large home he built west of the Chattahoochee was a social center for friends and travelers.

The Civil War brought an end to this life. Pace and his family took refuge in Milledgeville. His home was occupied and then burned by Federal troops. Pace died in Milledgeville and is buried on Vinings Mountain.

Hilarie Johnston, artist 1987

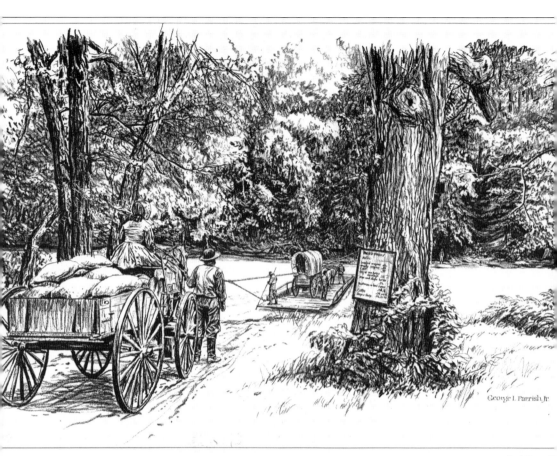

The ferry crossing the Chattahoochee River was one of Hardy Pace's many enterprises. The service was started by the Cherokees as Harris Ferry in the early 1830s and continued even after the start of rail service between Atlanta and Marietta and points north. A planked iron truss bridge across the Chattahoochee River was finally built in 1904 to complete service on Paces Ferry Road. (Courtesy of the Vinings Historical Preservation Society.)

Two

THE CIVIL WAR

The Western & Atlantic Railroad, which connected Atlanta to Chattanooga, served as the battle path of the Civil War in western Georgia. The area was frontier, with the Indians not long removed. Supplies and people moved on rivers or by rail. The railroad became the Confederate lifeline and the path for the Union Army of the Cumberland to move south.

To protect Atlanta, a defensive line was built in 1864 called Johnston's River Line. Its purpose was to stop Sherman's attack on Atlanta by using massive earthworks built with a labor force of over 1,000 slaves. The northern part of this defense extended into the Log Cabin area of Vinings. The line, designed by Brig. Gen. Francis Shoup, consisted of 36 arrow-shaped forts, or "shoupades," connected by a wall of log palisades and trenches. The Union army used flanking maneuvers and arrived at the Vinings railroad station on July 5, 1864, in pursuit of Gen. Joseph E. Johnston's Confederate army. The IV Corps of the Union Army took possession of Vinings Station and set up a headquarters for General Sherman in the Hardy Pace home. A signal and observation post was set up at the top of Vinings Mountain. The railroad station served as a railhead, telegraph office, and supply depot.

General Sherman remained in Vinings for 11 days while he planned the destruction of Atlanta and its Confederate army supplies. When General Sherman left, the home of Hardy Pace was burned, leaving only the stone steps to the house. Hardy Pace and his family had moved, along with other landowners, to Milledgeville, where Pace died on December 5, 1864. His body was later moved back and buried atop Vinings Mountain, currently known as Mount Wilkinson.

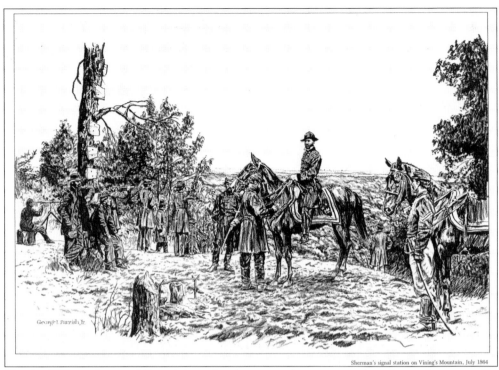

The Civil War in Georgia followed the railroad, as it was the conveyer of supplies to the armies. On July 5, 1864, General Sherman first viewed Atlanta from Vinings Mountain, also called Lookout Mountain by Union forces, as the IV Corps pursued Gen. Joseph E. Johnston's Confederate army. During the battle, the vantage point was used by artillery to shell the retreating Confederate rearguard crossing at Paces Ferry. The mountain remained as an observation and signal station throughout the Battle of Atlanta. (Both courtesy of the Vinings Historic Preservation Society.)

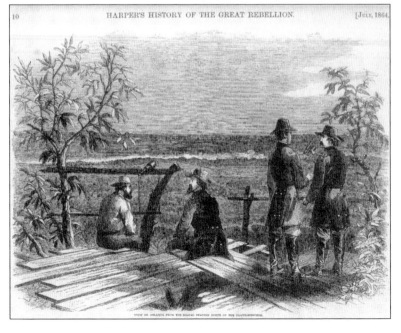

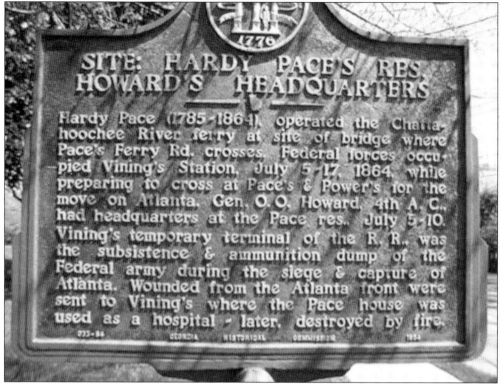

SITE: HARDY PACE'S RES.,
HOWARD'S HEADQUARTERS

Hardy Pace (1785-1864), operated the Chatta-
hoochee River ferry at site of bridge where
Pace's Ferry Rd. crosses. Federal forces occu-
pied Vining's Station, July 5-17, 1864, while
preparing to cross at Pace's & Power's for the
move on Atlanta. Gen. O. O. Howard, 4th A. C.,
had headquarters at the Pace res., July 5-10.
Vining's temporary terminal of the R. R., was
the subsistence & ammunition dump of the
Federal army during the siege & capture of
Atlanta. Wounded from the Atlanta front were
sent to Vining's where the Pace house was
used as a hospital – later, destroyed by fire.

During July 1864, the rail station at Vinings played an important part in the Atlanta Campaign. Hardy Pace and his household fled to Milledgeville, and General Sherman moved in, using the house as his headquarters and later as a hospital. The area around the rail station was used as a railhead, telegraph office, supply depot, and hospital. The Confederate army had cut the rail tracks in two places, but the first train from the north was able to arrive on July 7 with construction supplies. Vinings Station remained a supply depot for Federal troops and military government personnel until well after the war ended. (Both courtesy of the Vinings Historic Preservation Society.)

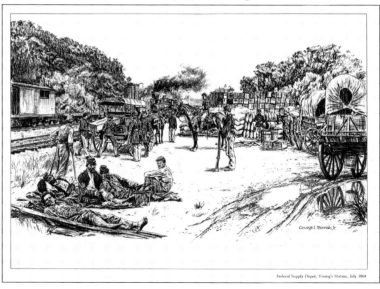

Federal Supply Depot, Vining's Station, July 1864

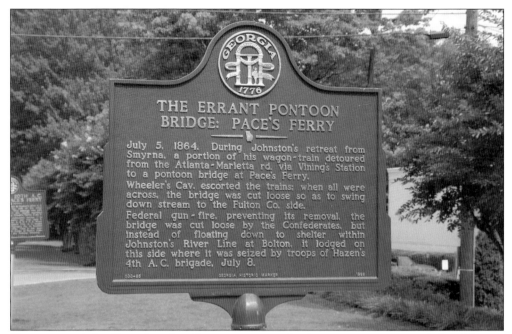

GEORGIA 1776

THE ERRANT PONTOON BRIDGE: PACE'S FERRY

July 5, 1864. During Johnston's retreat from Smyrna, a portion of his wagon-train detoured from the Atlanta-Marietta rd. via Vining's Station to a pontoon bridge at Pace's Ferry.

Wheeler's Cav. escorted the trains; when all were across, the bridge was cut loose so as to swing down stream to the Fulton Co. side.

Federal gun-fire, preventing its removal, the bridge was cut loose by the Confederates, but instead of floating down to shelter within Johnston's River Line at Bolton, it lodged on this side where it was seized by troops of Hazen's 4th A.C. brigade, July 8.

030-85 GEORGIA HISTORIC MARKER 1988

Troops crossed the Chattahoochee River on pontoon bridges at various sites, including Vinings at Paces Ferry. Federal troops arrived in Vinings in pursuit of the retreating Confederates, who had been crossing the river using a pontoon bridge. As the last of the Confederates crossed, while being shelled from atop Vinings Mountain, they cut the pontoon bridge free, expecting it to float downstream; instead, the pontoon swung across the river, allowing it to be captured by Union soldiers and reused in their crossing. Vinings also includes the northern part of Johnston's River Line, a defensive line west of the Chattahoochee created to stop the Union army's crossing. The defense was not successful, and Confederate president Jefferson Davis replaced General Johnston with Gen. John Bell Hood. (Both courtesy of the Vinings Historic Preservation Society.)

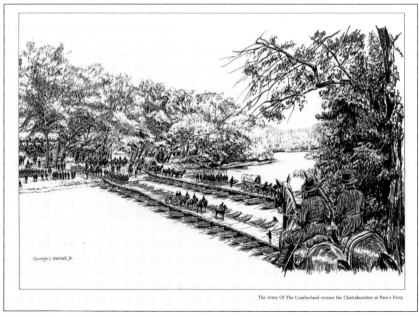

George L. Parrish, Jr.

The Army Of The Cumberland crosses the Chattahoochee at Pace's Ferry

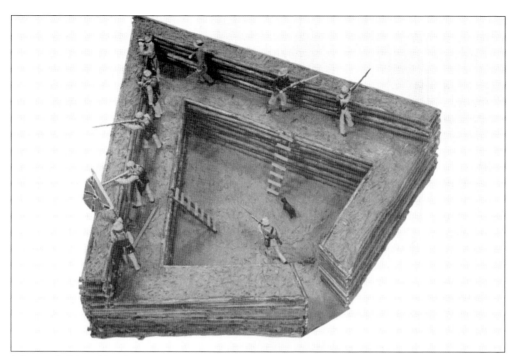

Johnston's River Line is a National Historic Landmark. According to Marion Blackwell Jr., it is a series of earthworks "significant because it includes unique fortification called Shoupades. . . . These fortifications were arrowhead-shaped infantry forts made of log walls 10 to 12 feet high, and could accommodate up to 80 soldiers." The scale model is displayed at the Kennesaw Mountain National Battlefield Park. The fort's designer, Gen. Francis M. Shoup, became an Episcopalian priest after the war and taught at the University of the South. (Both photographs from *The Chattahoochee River Line* by William Robert Scaife and William E. Erquitt with permission from the Kennesaw Mountain Historical Association.)

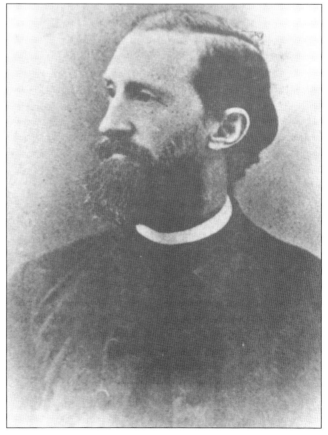

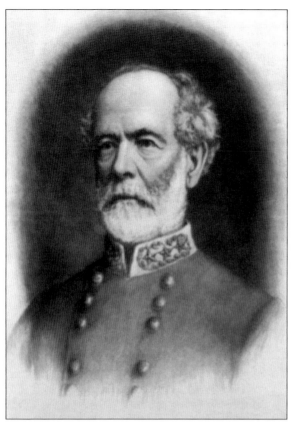

Joseph Johnston (1807–1891) was the commander of the Confederate army that faced General Sherman's advance from Chattanooga to Atlanta. A West Point graduate and military engineer, Johnston created strong defensive positions using available slave labor only to see General Sherman outmaneuver and flank him, causing retreat after retreat towards Atlanta. General Johnston formed the Johnston River Line to protect Atlanta, but General Sherman used Vinings to bombard his positions and drive his troops across the river. (Courtesy of the Library of Congress.)

These Civil War reenactors show the current delicate condition of the shoupades and artillery forts along the River Line. Preservation is promoted by several groups, as these sites are often in the path of housing developers. (Photograph from *The Chattahoochee River Line* with permission from the Kennesaw Mountain Historical Association.)

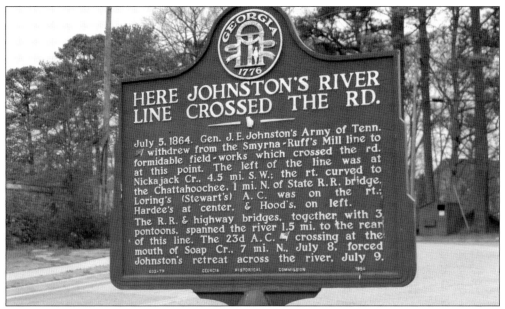

There are several Civil War historical markers in close proximity near the Chattahoochee River in Vinings. The importance of the river crossing is documented by these markers and by history. There were defenses, retreats, advances by the Union troops, and changes of position centered in this area. One of the distinctive features of Vinings is the neighborhood's dedication to historic preservation. (Courtesy of Ross Henderson Photography.)

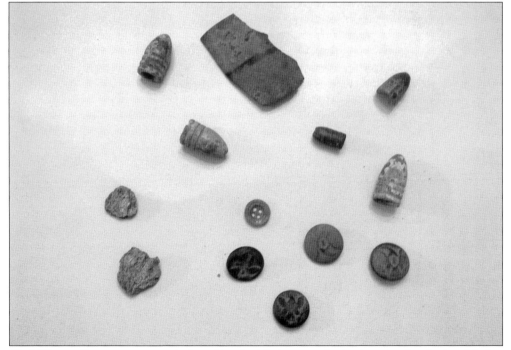

Civil War artifacts are commonly found in the Vinings area by backyard archeologists. Musket balls, bullets, buttons, and buckles are the most frequent items found; however, some of the artifacts have included live artillery shells. (Artifacts courtesy of Janet Dickerson.)

Steps are the only remains of Hardy Pace's first house after it was burned by the Union army. When Solomon Pace returned and built a new house, these steps were used; they still exist and are now part of the Solomon Pace House, maintained by the Vinings Historical Preservation Society. The home was a part of the vast destruction in North Georgia. Trees were cut for firewood, cattle had been slaughtered for food, and the fields were stripped of crops. The Union army destroyed artillery rounds by setting them off in Vinings itself. As recently as 2006, a Civil War relic collector was injured when a Parrott shell exploded at his home. Hundreds of tons of iron metal were left along the countryside after the troops left. (Courtesy of the Vinings Historic Preservation Society.)

Three

HISTORIC VININGS

By the 1880s, Vinings was a prospering community of approximately 75 residents, according to historian Beverly M. DuBose Jr. The community included a gristmill, blacksmiths, a druggist, and several nearby farmers and planters.

Hardy Pace had left Vinings during the war and died in Milledgeville in December 1864. His remaining children (Parthenia, Catherine "Carton," and Solomon) returned to Vinings after the war with his remains and buried him atop Vinings Mountain. Solomon Pace rebuilt a new home on the foundation of the original Pace House, which included one or more slave houses. It is told that Solomon made the original house by combining three slave houses under one roof. He and his sisters' families (the McAfees, Kirkpatricks, and the Randalls) sold and exchanged property, consolidating much of the area into its current configuration.

The Vinings community has a large creek, Little Nancy Creek, located below Mount Wilkinson (Vinings Mountain), which attracted the attention of Rufus Rose, the founder of Four Roses bourbon whiskey. He built the distillery in the late 1860s to use the pure water and hauled barrels by oxcart to the Vinings depot, where distilling supplies of corn and sugar were picked up. The distillery was in operation until prohibition laws were enacted in 1907, at which time the operation was moved to Chattanooga.

According to Mr. DuBose, in 1891 photographer E. Warren Clark discovered the famous old locomotive the *General* occupying a sidetrack in Vinings. Two movies were made about "The Great Locomotive Chase of 1862." The first movie was *The General* in 1927; it was silent and starred Buster Keaton. Clark proposed rehabilitating and displaying the engine at the 1893 World's Columbian Exposition in Chicago as a tribute to Confederate captain William A. Fuller, who captured it long before. The restored engine was used to promote the Disney movie *The Great Locomotive Chase* in 1956 and now resides at the Kennesaw Train Museum.

Part of a wall and a dam support are all that remains of the Four Roses distillery along Little Nancy Creek. Although Rufus Rose was originally from New York City, he came to Georgia, married, and fought for the Confederacy. He founded Four Roses bourbon whiskey and built his distillery along Little Nancy Creek in 1867. The bourbon was shipped from the train depot for bottling in Atlanta. (Both courtesy of Ross Henderson Photography.)

In May 1902, a fire destroyed the distillery, and another one was built in what is known as the Gilmore location, which also had a rail depot. This spot would be in the Cumberland Parkway area near the fire station. Remnants of the brick warehouse stood for many years until they were used to rebuild Robinson's Tropical Garden after fire destroyed the wooden structure. (Both courtesy of the Vinings Historical Preservation Society.)

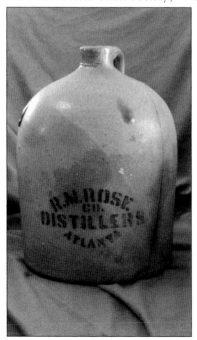

John Carmichael was an entrepreneur in the Log Cabin area of Vinings. The photograph of the Carmichael Farm Blacksmith Shop was taken around 1919. The store was located in the Log Cabin community along the Dixie Highway and the Atlanta Northern Railway's trolley line. (Both courtesy of the Smyrna Historical Association.)

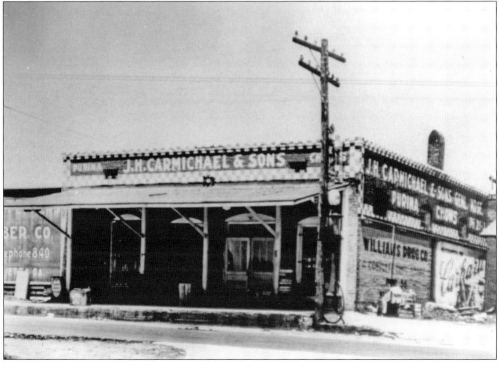

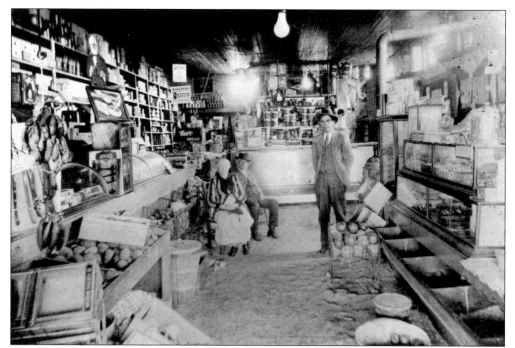

This image of the interior of the J.H. Carmichael General Store was taken in 1920. From left to right are Emma Stanback Carmichael, J.H. Carmichael, and owner John Vinson Carmichael. John Carmichael's son James V. Carmichael was an active Cobb County attorney and politician in the 1940s and 1950s. He was general manager of the Bell bomber plant during World War II. He ran for governor of Georgia in 1946. (Courtesy of the Smyrna Historical Association.)

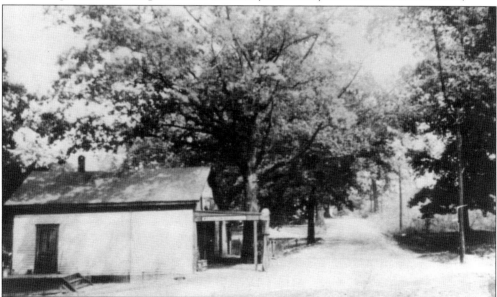

This dirt road is the Vinings intersection of Paces Ferry, Paces Mill, and Mountain Road, seen around 1930. The building was constructed around 1890 and is shown as Ferguson's general store and gas station before the stone facade was added as well as rooms to the rear. This area was known for its large shady oak trees. (Courtesy of the Vinings Historical Preservation Society.)

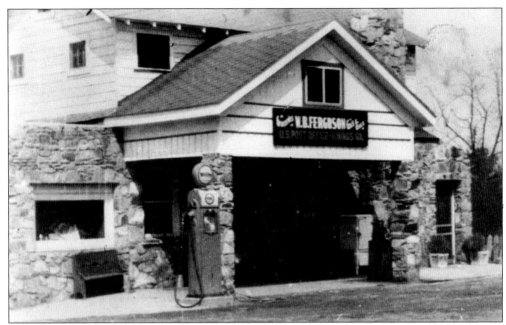

Around 1929, Ferguson's added the stone facade that is so familiar even today. His was the only gas station in Vinings in those early years. After Ferguson's store vacated, the building was rented to other enterprises and eventually became the Old Vinings Bar and, in the 1990s, the Old Vinings Inn. (Courtesy of Mr. and Mrs. Walter C. Butler Jr.)

In 1904, a one-way planked iron truss bridge was built across the Chattahoochee River, uniting Paces Ferry Road in Cobb County and West Paces Road in Fulton County. This bridge allowed motor traffic to pass from Cobb County to the city of Atlanta and to Buckhead. Around the turn of the century, wealthy Atlanta families were building summerhouses in the Vinings area. The summers were pleasant out of the city with the cooler temperatures, surrounded by the scenic beauty of Vinings. (Courtesy of the Vinings Historic Preservation Society.)

The trolley line from Atlanta to Marietta had two stops in the Log Cabin area of Vinings: Log Cabin and Carmichaels. The line was the first interurban route of the Atlanta Trolley, traveling up to Marietta and providing service to the Bell bomber plant during World War II. The line opened in 1905, with the last streetcar running on January 31, 1947. The trolley stop has become a pocket park along Log Cabin Road. (Courtesy of Jen Case, photographer.)

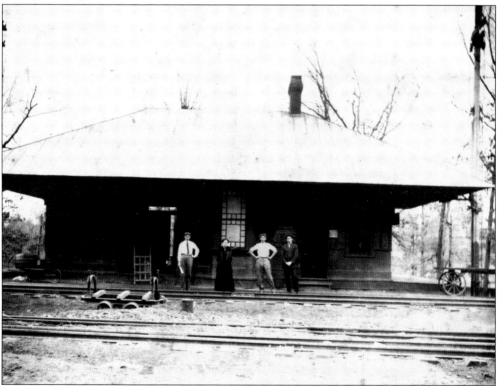

Vinings Station had a small staff. Pictured from left to right are John Tatum, Maggie Phillips Tatum, Grady Cannon (the telegraph operator at his first job), and an unidentified employee. Even though Vinings was a small community, the train brought the mail daily. Small communities were not often served so frequently. (Courtesy of the Smyrna Historical Association.)

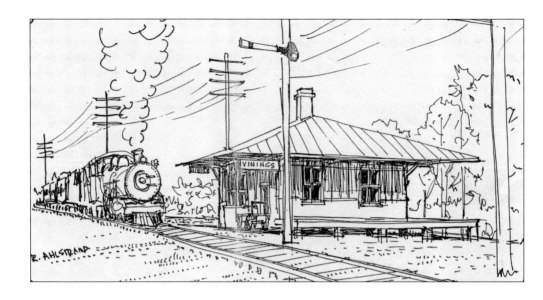

The Vinings Station, as shown in the above sketch, was a combination freight and passenger station. It was a wood structure with white and colored waiting rooms, an agent's office, and a freight warehouse. The platform was on three sides. Train signals were semaphore and on a wooden mast that was hand-operated from the telegraph office. There was a mail hook for the daily delivery. The train is possibly the *Dixie Flyer*, seen around 1950 as identified by Anthony Doyle. (Both courtesy of the Vinings Historical Preservation Society.)

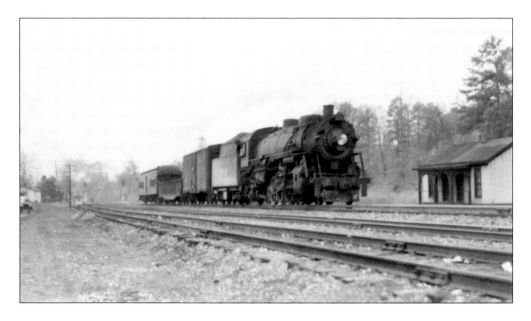

John Tatum was the stationmaster at Vinings Station in the early part of the 20th century. He later became stationmaster in Smyrna, considered a promotion. Shown are his train passes from 1911. (Courtesy of the Smyrna Historical Association.)

This 1891 train timetable shows how important trains were for freight and passengers. The roads were dirt and often difficult to traverse because of mud, thus there were many train stations located just minutes apart. The timetable between Marietta and Atlanta shows stops at Marietta, Smyrna, Vinings, Gilmore, Bolton, Simpson Street, and Atlanta—seven stations in about 20 miles. (Courtesy of Robert and Peggy Ahlstrand.)

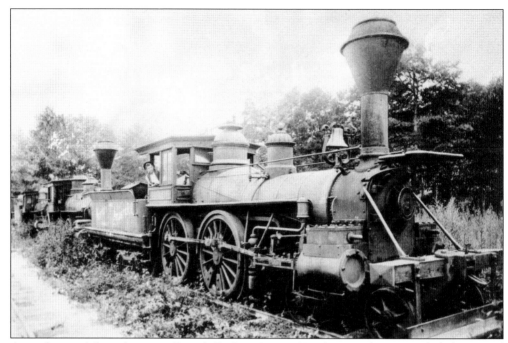

According to Atlanta historian Beverly DuBose Jr., in 1891 photographer E.W. Clark discovered the famous old locomotive *The General* on a side track in Vinings. In 1892, the engine was refurbished and appeared in 1893 at the World's Columbian Exposition in Chicago before going on permanent display at the Union Depot in Chattanooga from 1901 until 1961. In 1972, *The General* was presented to Gov. Jimmy Carter and was delivered to Kennesaw, Georgia, at a site donated by the Frey Family of Kennesaw. (Courtesy of Robert and Peggy Ahlstrand.)

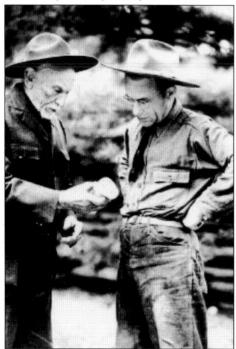

Daniel Carter Beard (left) met Ed Dodd at Camp Bert Adams. Beard was a founder of the Boy Scouts of America. He was also a noted artist and ran a private boys' camp in Pennsylvania. Dodd worked for Beard for 13 years and was mentored by Beard in art. Dodd broke into the comics business and is best remembered for his *Mark Trail* comic strip, which featured wild animals. (Courtesy of Bert Adams Boys and Tom Watson.)

Four

VININGS ON A SUNDAY AFTERNOON

Vinings is a part of the Piedmont Plain, with the Chattahoochee River meandering—and sometimes flooding—this area of scenic beauty. The riverbank has rocky outcroppings that provide stepping-stones or sometimes vistas. The low land near the river rises quickly into hills, topped by Vinings Mountain. Vinings was a Sunday type of place. People who lived there have fond memories of fishing or picking blackberries along the roadsides. The lucky ones would find Indian arrowheads or Civil War bullets.

After the war and Reconstruction, the Western & Atlantic Railroad was leased by Gov. Joseph M. Brown, who built five pavilions to encourage railroad excursions. These all-day expeditions from Atlanta to Vinings became popular with church groups, school groups, and families looking for a pastoral setting outside Atlanta. Excursions remained popular through the 1960s and 1970s, as ladies came out of the city for a day of antiquing, shopping, and lunch.

Around the beginning of the 20th century, some Atlanta residents began building summer places close to the riverbank or nestled on the shady hills. There was easy access by rail, and after 1904 the bridge allowed travel by buggy and then auto. Some of these land holdings and dwellings became extensive. William J. Davis of Atlanta expanded his house to two stories and his property along the Chattahoochee to about 200 acres. This was later sold for the Cochise subdivision. Others moved their permanent residences to the bucolic area.

There was a stock-car racetrack in Vinings in 1928. It was described by Norman Robinson in an interview with Jody Smith as having a dirt track and a wooden grandstand a third of the way around it. The Robinsons ran the concession stand. The track went bankrupt, but many sources refer to the track grading, which remained where Paces Ferry Road crosses the river.

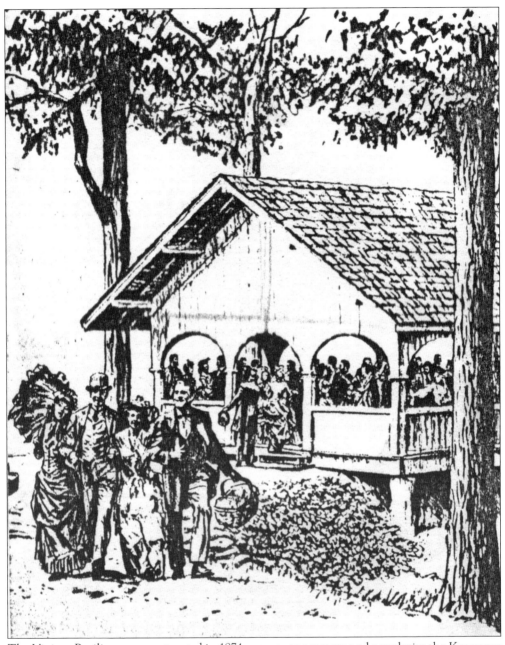

The Vinings Pavilion was constructed in 1874 as a way to promote and popularize the Kennesaw Route of the Western & Atlantic Railroad. It was built near the Vinings train depot as an open-air structure. There was dancing, food, and courting, along with shade for lounging and enjoying a day away from the city. (Courtesy of Robert and Peggy Ahlstrand.)

You are cordially invited to attend a

Pic-Nic at Vining's,

Saturday, May 3rd, 1884.

CHAPERONES.

Mrs Wolford, Mrs. Orme, Mrs. Barker, Mrs. Dooly,
Mrs. Inm n, Mrs Reed.

COMMITTEE.

TOM. AUSTIN,
WILL. PRESCOTT, LITT BLOODWORTH,
SIM. POST, WILL. MATHEWS,

Train leaves at 7:30 A. M. Returns at 5 P. M.

This invitation was addressed to Miss Sallie Fannie Grant (later the wife of Governor John Marshall Slaton). It is, in 1978, in the possession of Mr. & Mrs. A. Waldo Jones, of Vinings, Ga.

Elaborate invitations were issued for these pavilion affairs. This one has train transportation provided for an 1884 affair. The names of the chaperones and sponsors were prominently featured. This invitation was sent to Sarah Francis (Sallie Fannie) Grant, who later married Georgia governor John Marshall Slaton. (Courtesy of the Vinings Historic Preservation Society.)

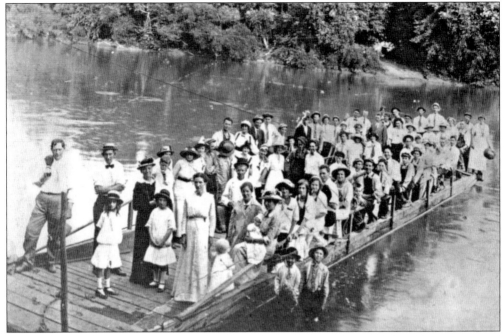

The DeFoors Ferry shows an outing from 1910. This would have been similar to Paces Ferry. By the beginning of the 20th century, ferry rides were recreational, as Chattahoochee River crossings then were served by bridges. Ferries were still a fine way to cool off on a hot summer afternoon. (Courtesy of the Vinings Historic Preservation Society.)

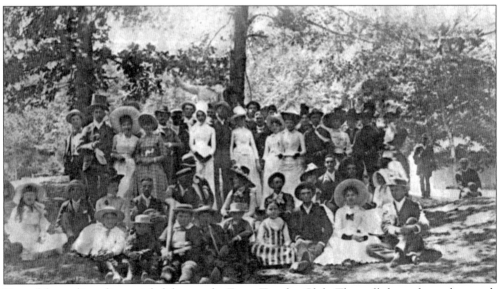

One of the earliest elite social clubs was the Every Tuesday Club. The well-dressed members took weekly outings to Vinings for lounging in the shade and dancing at the pavilion. There was a Vinings Tea House, even back then, to provide lunch. (Courtesy of Robert and Peggy Ahlstrand.)

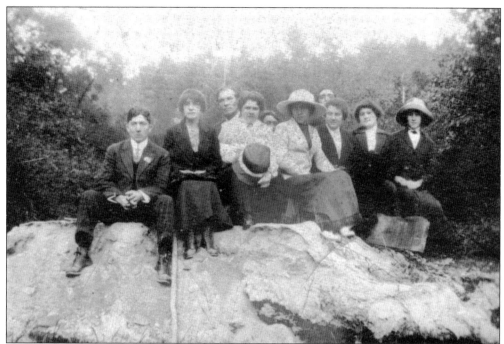

These are images from Earle Carter's photo album. No names are associated with them, but the general feeling of fun and freedom that existed during these outings resonates. (Both courtesy of Mandy Ford Bubel.)

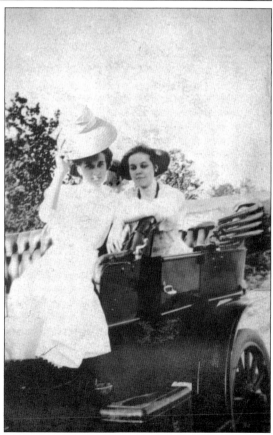

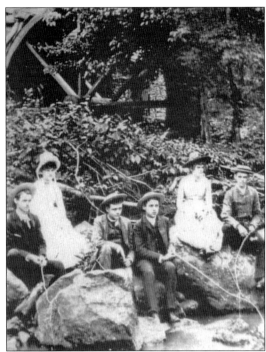

The river and shade provided for an escape from the city. The posed shot below of the two couples is a more circulated photograph and has been used in local commercial printing. (Both courtesy of Mandy Ford Bubel.)

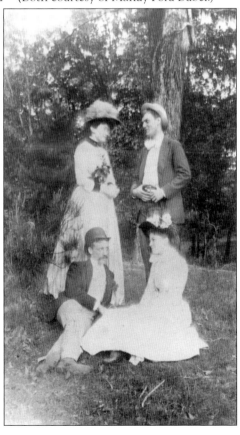

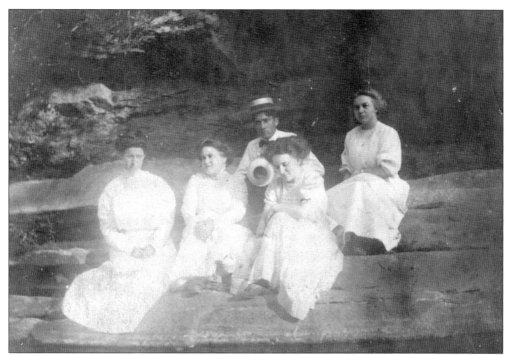

The Chattahoochee provided the backdrop for both of these album photographs. Again, names are lost except for Jim and Albert, paddling along the river. According to reminiscences of Janet Moore Bryan, the river was also a popular place for skinny-dipping. (Both courtesy of Mandy Ford Bubel.)

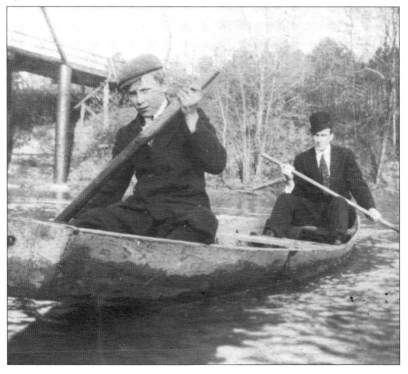

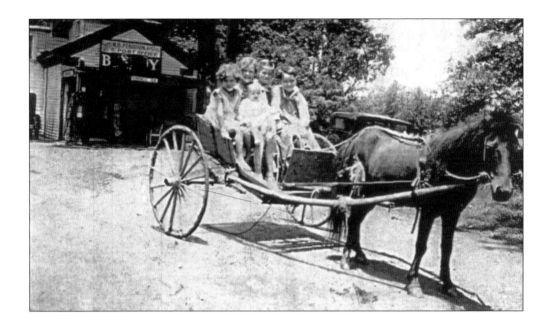

While some people visited Vinings only for a Sunday afternoon, the families who lived in the community had a close, warm relationship with each other. The Yarbrough, Robinson, and Ferguson children play in front of Ferguson's store and gas station in the mid-1930s. Above are, from left to right, Jackie Yarbrough, Agnes Robinson, Pace Yarbrough, and Willy Ferguson, with infant Patsy Ferguson in front. Below are, from left to right, Pace, Agnes, Willie, Patsy, and Jackie. (Both courtesy of the Vinings Historic Preservation Society.)

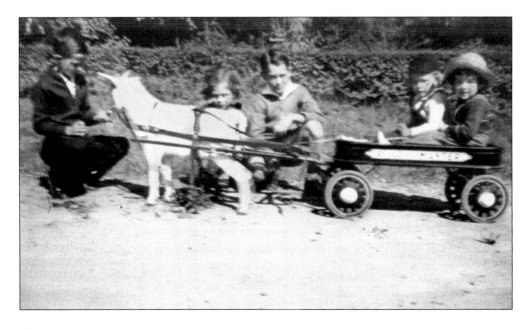

During this time, it was common practice for families to hire domestic help from the African American community in Vinings. At right, Patsy Ferguson (right) goes for a pony ride with her nurse, Mary Story; Jackie Yarbrough is in the center. Below, Mary is holding Patsy. Since these families lived in the community, a lasting relationship between child and caregiver developed. (Both courtesy of the Vinings Historic Preservation Society.)

Overland Automobile Owned by John Tatum
Auto was purchased on April 22, 1916.
Manufactured by the Willys-Overland Company, Toledo, Ohio
Serial Number 88079, Model 83B
Photo was taken in front of Tatum Residence in Vinings, GA.
Note corn patch and house on left.

INSTRUCTIONS FOR THE OPERATION OF OVERLAND CARS

The right way FIG. 5 The wrong way
Have tires properly inflated

Starting the Motor

These few details attended to, you are ready to start the motor.

Before you can do so, however—in fact, before you can start the motor at any time—you must make certain of three things:

1—That the ignition switch, which is the lower lever on the steering column switchbox, is pushed in a position as indicated in Fig. 6.

2—That the gear-shifting lever is in neutral position, that is in the center of the H-shaped shifting gate. (Fig. 7.)

3—That the spark and throttle levers are in the proper position for starting. (Fig. 8.) The spark lever should be about one-third of the way up the quadrant. Both levers are retarded when they are in their lowest position.

John Tatum, stationmaster of the Vinings railroad depot, poses in his 1916 Overland automobile. With the building of Paces Ferry Bridge, automobiles became more common. Due to their still-fragile nature, car travel was usually limited to relatively close destinations; longer distances were relegated to train travel. The auto's specifications are given on the flyer. Tatum went on to be promoted to stationmaster of Smyrna. (Courtesy of the Smyrna Historical Society and Museum.)

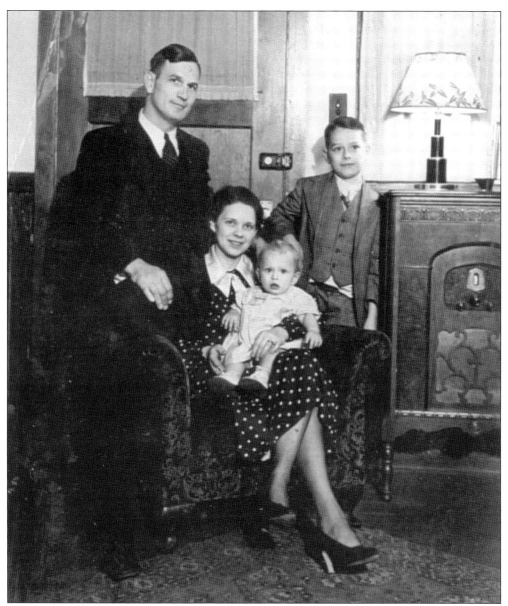

The Yarbrough family home illustrates a comfortable household of the 1930s. Mother Margaret Weldon Yarbrough had been a teacher at the original Vinings Public School. Here, she is shown with Jackie and Pace along with her husband, Walter Pace Yarbrough. Walter started as a miller around 1900, but by 1920 he worked for the railroad as a conductor. Margaret was his second wife—Walter was a widower—and with Margaret he had four children. (Courtesy of the Vinings Historic Preservation Society.)

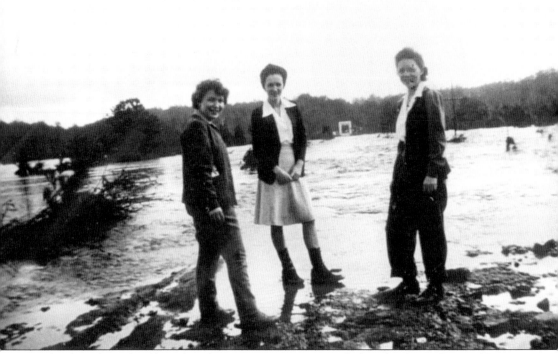

Flooding along the Chattahoochee was a common event before the Army Corps of Engineers built dams upstream and improved the river flow. From left to right, Dot Bacon, Carolyn McCook, and Irene Ferguson look at the high water during the flood of January 1946. The Chattahoochee reached around 26 feet. The 100-year flood mark is around 24 feet, and the bankfull level is 15 feet. (Courtesy of the Vinings Historic Preservation Society.)

Five

PEOPLE OF VININGS

As the adage goes, people make the place. Fortunately, Vinings had a stable community of families descended from Hardy Pace. In fact, Anthony Doyle shows that Solomon Pace, Tillman McAfee, and Hardy Randall made a series of land exchanges around 1870 that laid out the lots configuring the town plat for Vinings. The lots were designated on the map as "P" for Pace, "R" for Randall, and "M" for McAfee.

Atlantans came into Vinings following the railroad. They were the Yarbroughs, Fergusons, Hills, and Whitleys. They brought commerce in the way of shops, farms, and services. With the growth came amenities such as shops, the country club, the Boy Scout camp, and antiques stores. The Carter sisters, Earle and Ruth, played a big part in developing Vinings into what it is today.

While Earle Carter Smith was a force in Cobb County politics, Ruth Carter Vanneman reportedly had five husbands. She converted their money into her land, and with it she managed much of Vinings's development. There was contention with the Vinings Homeowners Association over her sale of the property to developers that is now the Vinings Jubilee development as well as other patches of land. She also donated land to the county for a fire station on Paces Ferry Road.

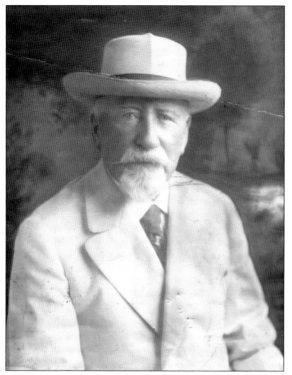

The builders of the Pace House were Solomon K. (1818–1897) and Penelope N. Glass Pace (1821–1904). Solomon was the surviving son of Hardy Pace. He enlisted in the Georgia Reserves during the Civil War and after his father's death was executor of the estate. Returning to find the family home burned, Solomon built his house on the same piece of property using salvaged materials. He and Penelope raised a friend's motherless child, Sarah Amanda Collier, as their own and were active in raising their nieces and nephews. They were also active in the Methodist Church and gave land and materials to build the Methodist church at Sardis in Fulton County. They often opened up their home to Methodist ministers and their families, who stayed for extended periods of time. (Both courtesy of Mandy Ford Bubel.)

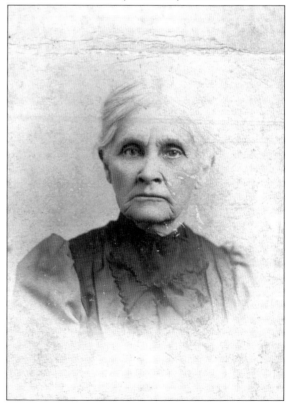

Solomon and Penelope Pace raised Sarah Amanda Collier (1847–1933) as their own, and she was adored but never adopted by them. In 1866, she married James Wallace Kirkpatrick in Fulton County. She and Wallace then built a home next to that of Solomon Pace. This photograph was taken around 1900. (Courtesy of Mandy Ford Bubel.)

Keren Pace was the daughter of Hardy and Lucy Pace. She and her husband, Tilman McAfee, are not as well documented as others in the Pace family. Tillman was shown to be a farmer with about nine acres of improved land and 190 acres of unimproved land. There are no exact records of their birth, marriage, death, or place of burial. (Courtesy of Mandy Ford Bubel.)

Hardy Isaiah Randall (1838–1912) was the grandson of Hardy Pace. His son Harvey Gatewood Randall started the family fuel business. It started with wood, and then coal, before Randall & Brothers started to sell and service fuel oil equipment as the Narjoe Timber and Supply Company. (Courtesy of the Vinings Historic Preservation Society.)

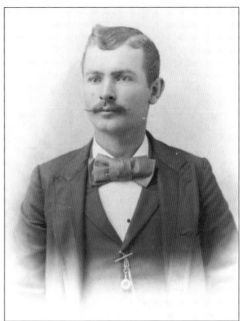

Clara Yarbrough Vest, in the upper left, was the mother of seven girls and died in 1906. Joel Andrew Vest, in the upper right, was Clara's husband. The baby to the left is Albert Yarbrough. (All courtesy of the Vinings Historic Preservation Society.)

Albert "Bert" Adams (1879–1926) was in Atlanta real estate in the early 20th century. He was a charter member of the Atlanta Rotary Club and president of Rotary International in 1919 and 1920. He was president of what was then the Atlanta Council of the Boy Scouts. In that position, he sought a permanent spot for the council's summer camp. He found the spot in Vinings, overlooking the Chattahoochee River. He died shortly before the dedication of the camp named in his honor. (Courtesy of the Vinings Historic Preservation Society.)

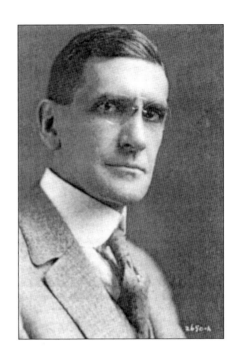

Edna Earl Kirkpatrick Carter (1869–1960) and her husband, Charles LaFayette Carter (1860–1934), sit on their house porch posing for this photograph around 1910. They are shown with three of their six children, from left to right, Jim, Ruth, and Kirk. (Courtesy of Mandy Ford Bubel.)

This portrait of Edna Earl Kirkpatrick Carter hangs in the Pace House. She was the great-granddaughter of Solomon Pace's "not by blood" daughter Sallie Collier. She was the mother of six children, two of whom—Pauline and Sarah—died in infancy or early childhood. The surviving siblings were Earle Carter, Thomas K. Carter, James A. Carter, and Ruth Carter. Ruth was a most colorful character and shaped much of what Vinings is today. (Courtesy of Mandy Ford Bubel.)

Earline "Earle" Carter (1888–1992) was married to William B. Smith (1875–1950). She and her sister Ruth were public figures in Vinings. She was called "the unofficial mayor of Vinings" for her involvement with the community. In the 1940s, she bought the pavilion, enclosed it, and then leased it to antique dealers. (Courtesy of Mandy Ford Bubel.)

Ruth Carter Vanneman (1900–1992) was the often-married (a rumored five times) daughter of Edna and Charles Carter, and she was given the title "the Duchess of Vinings." She was a well-known person and was often quoted in the press about Vinings as it developed and changed. She had a large amount of real estate and used the sale of land to control and manage Vinings's growth. (Courtesy of Mandy Ford Bubel.)

James V. Carmichael (1910–1972) was born and raised in the Log Cabin area of Vinings, where his father, John V. Carmichael, had a general store, farm, and other holdings. James rose to prominence as a Cobb County attorney, a member of the Georgia Legislature, and manager of the Bell bomber plant during World War II. In 1946, he ran for governor of Georgia. (Courtesy of the Log Cabin Church.)

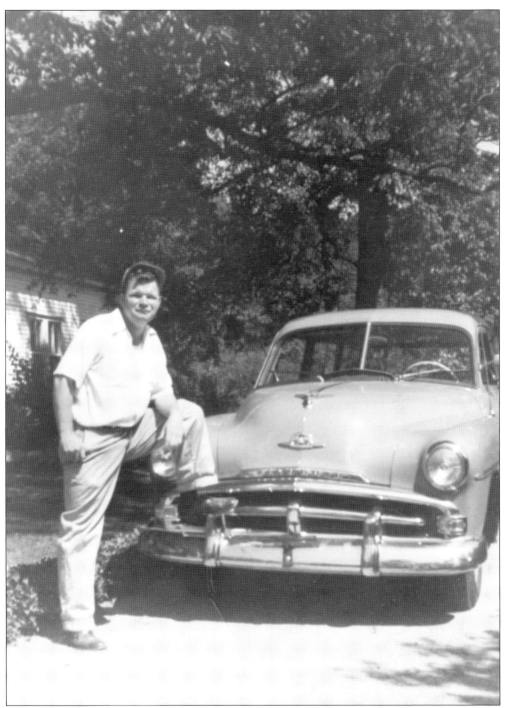

Noah Duckett (1922–1996) was often called "the greeter of Vinings." He was the good-natured handyman who often helped out Ruth Vanneman and the other residents. In the 1940s, he hung the mailbags at the Vinings Station and waved at passing cars. He was not educated but was happy to be of help to the community. It was his habit to walk to Buckhead on Saturdays to watch a movie and then catch a ride home. (Courtesy of Ann Konigsmark Johnson.)

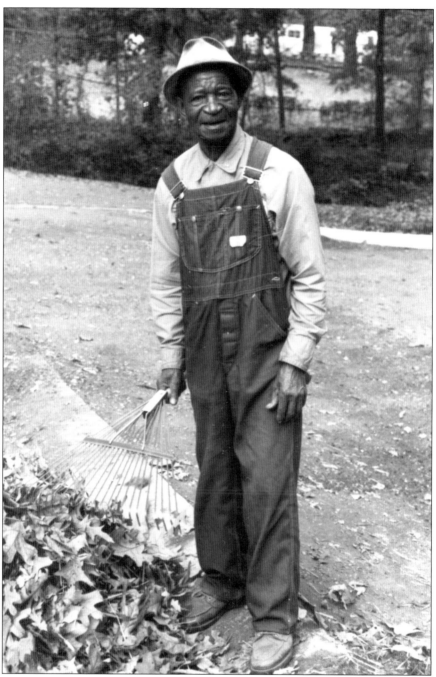

Willie "Uncle Jack" North was a respected leader in the African American community of Vinings; he was also a railroad worker and filled in at local jobs. Upon retirement, he often worked as Ruth Vanneman's gardener and found local employment for other members of the community. He was a deacon at Mount Sinai Baptist Church and lived at the top of Vinings Mountain. Uncle Jack was the one who took care of his community and made sure children went to school and people were cared for. He has an honorary grave marker in the Mount Sinai cemetery. (Courtesy of Robert and Peggy Ahlstrand.)

Six

STRUCTURES OF OLD VININGS

Writers of Vinings's development often refer to the style of the village as "New England" with white frame structures. While these structures dominate the architecture of the community, the tie-in with New England may have more to do with the frugality of both places. Traditional Vinings does have a predominance of white frame structures with metal roofs; materials for these structures were readily available within the community.

The village layout, the basic crossroads structure of Vinings, existed long before paved roads and traffic signals. Crossroads was the community framework set up in the post–Civil War era by Hardy Pace's descendants.

The large oak trees were important, offering shade to houses before the advent of air-conditioning. It was the appealing nature of the community, with plenty of shade, which attracted visitors from Atlanta. The antique shops and restaurants that served them were interspersed with residences. The early houses had enough land to raise chickens and vegetables. If they were prosperous enough, families would have had a stable/carriage house. Everyone in the community, of course, had a privy.

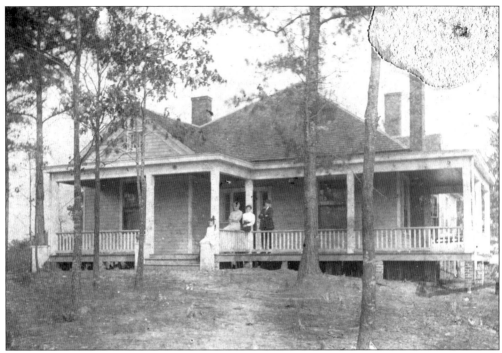

The Carter house was built close to the Pace House. It was the home of Wallace and Sarah "Sallie" Amanda Collier Kirkpatrick. This photograph was taken in 1904 or 1905 after Wallace had passed away. It shows, from left to right, Ruth Carter Vanneman (age four or five), Sallie Kirkpatrick, Edna Earl Kirkpatrick Carter, and Charles Carter. (Courtesy of Mandy Ford Bubel.)

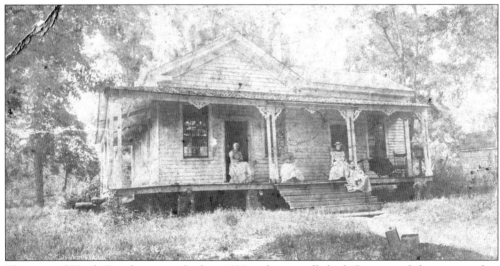

The original Hardy Pace house was built in 1832 and reportedly had 17 rooms, while some say that the 17 rooms included all of the outbuildings. It was vacated during the Civil War when Hardy Pace left for Milledgeville and was used as a headquarters for General Sherman for 11 days during the Atlanta Campaign. Upon leaving the site, Union troops burned the house along with many other Cobb County structures. The house was rebuilt in 1865 by Solomon Pace using parts of three slave cabins under a single roof as he used the old foundation; he preserved the original stone steps as well. This photograph is of the Pace House in 1903. (Courtesy of Mandy Ford Bubel.)

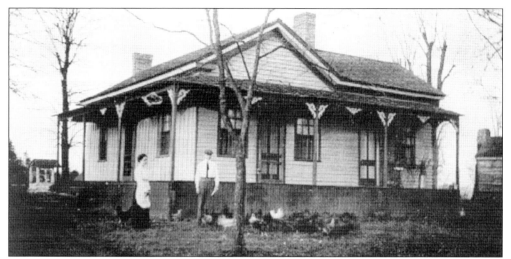

John Tatum, the stationmaster for Vinings Station, lived in Vinings from 1907 to 1922. His home gives an example of middle-class life in the early 20th century. The Tatum family raised their own poultry and vegetables. In the image, the well is seen off to the left side, while a neighbor's house can be seen to the right. John Tatum was promoted to stationmaster in Smyrna and became mayor of the city in the 1920s. (Courtesy of the Smyrna History Society and Museum.)

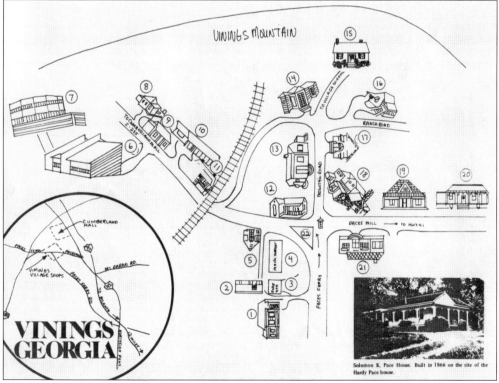

This map depicts the center of Vinings and was distributed as a guide for shopping in the 1960s and 1970s. It shows the fire station and the Earle Carter Memorial Fountain, and at the time Majik Market was still at the corner. Many of the marked buildings were antique shops. Building no. 7 was the Vinings Ski Ridge area. (Courtesy of Robert and Peggy Ahlstrand.)

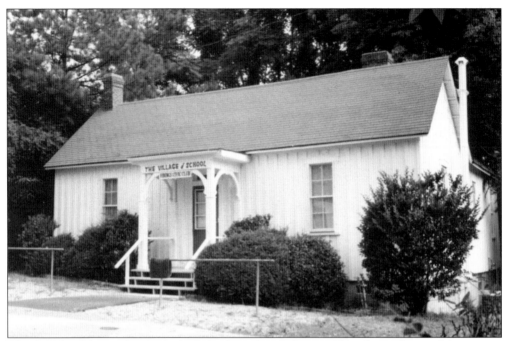

This board-and-batten house was built by the railroad about 1905 as the residence of the section foreman. Earle Carter Smith and Ruth Carter Vanneman purchased it in 1954. They moved it to Mountain Street and donated it to the Vinings Civic Club, which leased the building for use as the Vinings Village School. It was a private school with one teacher, Elda Bolt, who specialized in teaching children needing extra help. (Both courtesy of the Vinings Historic Preservation Society.)

The Pace House, as seen today, is a one-story frame house with porches on two sides. The stone steps are from the antebellum Pace home. A Georgia State Historic Marker gives the details of the Civil War battle that took place there. (Courtesy of the Vinings Historic Preservation Society.)

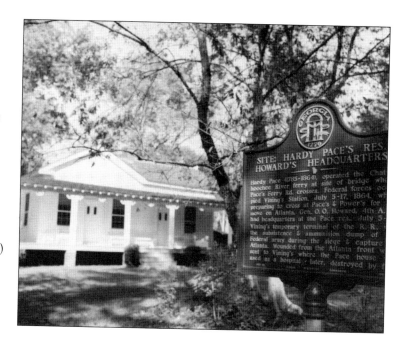

The Pace House parlor contains the writing desk, which is an original piece that belonged to Hardy Pace. (Courtesy of Ross Henderson Photography.)

The Pace House is now a museum for the early village of Vinings and has been furnished with original and period furniture. The house is now in a complex with the Vinings Pavilion and is available to rent. (Both courtesy of Ross Henderson Photography.)

Famed Atlanta historian Franklin Garrett is pictured on the porch of the Pace House demonstrating its significance to the history of the Atlanta area. Garrett (1906–2000) was the official historian of Atlanta and author of the authoritative history *Atlanta and Environs: A Chronicle of Its People and Events.* He joined the Atlanta Historical Society a year after it was founded in 1926 and became its director after retiring as historian for the Coca-Cola Company. (Courtesy of Robert and Peggy Ahlstrand.)

The Old Pavilion House was built by the Western & Atlantic Railroad, under lease to former Georgia governor Joseph M. Brown, as a place for a day's excursion from Atlanta. The pavilion provided a place of shelter for visitors as well as to congregate and to dance. Earle Carter Smith acquired the property in the mid-1940s, enclosed the pavilion, and opened it as an antique shop. The land with the pavilion was sold, and the pavilion was scheduled for demolition. In 1995, the civic associations of Vinings raised money to move the structure next to the Pace House as part of the museum complex. (Courtesy of the Vinings Historic Preservation Society.)

The Carter-Vanneman House was built in 1893. The original frame house was enlarged and a porch added across the front. Large oak trees shade the house and made it a gathering place over the generations. People walking by would be invited in for a drink with whomever was home at the time. The location has been redeveloped. (Courtesy of the Vinings Historic Preservation Society.)

The Kirkpatrick-Jones-Dunn House dates back to around 1875. It started as a white frame house similar to other county houses of the period with a large front porch and white fence. At mid-century, the owners remodeled the house: the 18-foot ceilings were lowered, a second story was added, and the exterior was designed in the Williamsburg style. The location has subsequently been redeveloped. (Courtesy of the Vinings Historic Preservation Society.)

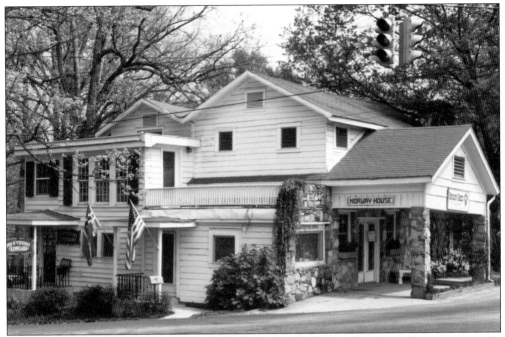

The Norway House was a corner landmark. It was originally a general store and gas station in the 1930s and 1940s. Apartments were added to the back, and an entrance was added on Mountain Street. The front of the Norway House was a bar called the Old Vinings Inn Bar. (Courtesy of the Vinings Historic Preservation Society.)

The structure at the crossroads was Ferguson's in the 1930s before it became the Vinings General Store. Marie Parker stands next to the only gas pump in Vinings, which sold gas for 13¢ per gallon in 1939. (Courtesy of the Vinings Historic Preservation Society.)

Earle Carter Smith started the move towards antique and curio shopping. Following her example, many of the existing residences were converted into shops. Buses from Atlanta would bring women out to Vinings for a day of shopping and lunch. Some of these shops were Wendy's Eagle, Olden Days Antiques, and the Vinings Antique Shop. It was during this time that the Vinings Old Pavilion House had seven different antique shops. (Both courtesy of the Vinings Historic Preservation Society.)

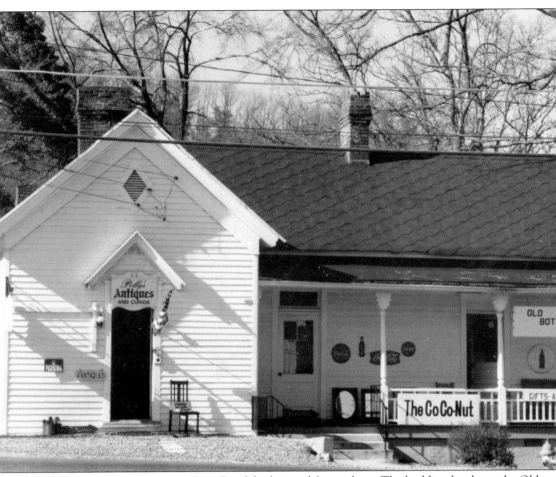

This antique store, on Paces Ferry Road, had several former lives. The building has been the Old Post Office and The Vest House, and currently it is a real estate office. According to Darlene Roth, PhD, who assessed the building in 1988, the "Vest House is one of the best examples of a Victorian "L" [shape] house adopted for commercial use in the country." During the antique shop days, Polly's Antiques was housed in one part of the building, the Co-Co Nut Gift and Antiques in another part, and the Old Bottle Shop had a third section. (Courtesy of the Vinings Historic Preservation Society.)

This small building was the original site of the Village Clothes Horse, one of the small shops serving the Vinings tourist trade. It was located on Mountain Road close to the Vinings Village School. The Vinings shopping guide describes it as a boutique, antique store, and candy shop. (Courtesy of Karen Cole Turner.)

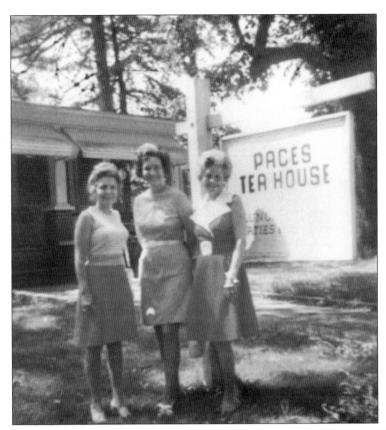

Women who came to Vinings in search of a nice afternoon of antique shopping and visiting with friends had lunch at the Vinings Tea Shop, which was in business for 24 years. It was a frame structure built by the Yarbroughs and was one of the early houses in the area. (Both courtesy of the Vinings Historic Preservation Society.)

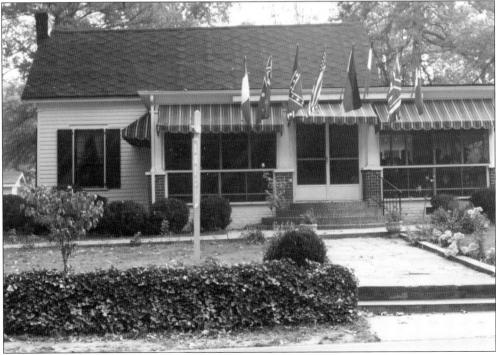

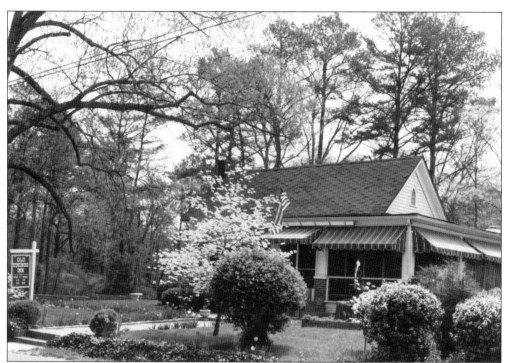

When the Vinings Tea Shop closed, Ruth Vanneman persuaded Bernard Stricker, owner of Bernard's on Collier Road in Atlanta, to take over the spot. He opened the ever-popular Old Vinings Inn. He managed the restaurant for 18 years until it closed in 1994. The property was sold to Piedmont Hospital for a medical center. The original building was returned to the community and is now the home of the Vinings Historical Preservation Society, although the look is entirely changed without the porches. (Courtesy of the Vinings Historic Preservation Society.)

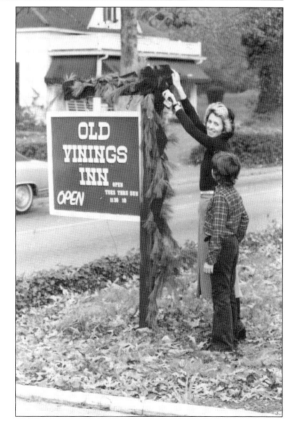

Holidays brought extra shoppers, and the Old Vinings Inn prepared for its holiday season. Early holiday reminiscences by Jeanet Moore Bryan told of a modest holiday earlier in the century with presents being fruit, nuts, and candy. (Courtesy of the Vinings Historic Preservation Society.)

Mr. Latimer's Red Store, a general store serving the Vinings community where Paces Ferry Road crosses the railroad track, saw plenty of foot traffic. Vinings Station Bakery replaced the store. It changed again to the present Orient Express, one of the most recognized restaurants in the entire Vinings community. (Both courtesy of the Vinings Historic Preservation Society.)

Seven

Schools, Churches, and Cemeteries

Vinings, as a community, had some of the first public schools in Cobb County. According to Sarah Blackwell Temple in *The First Hundred Years*, Vinings had both a white and a "colored" school starting around 1908. By the 1940s, the white school had moved, and the children were bussed out of the community. The "colored" school for grades one through three continued in Mount Sinai A.M.E. Church until integration in the 1960s. The older children continued their education at Rose Hill School in Smyrna, one of three public colored schools in Cobb County. In 1963, Teasley Elementary School opened to serve the Vinings community and the surrounding area. The Vinings Civic Club leased its clubhouse building to a private school that had just one teacher, Elda Bolt, a reading specialist who worked with early-elementary-aged children.

Churches were established early in Vinings. The Log Cabin Church was created in 1902 as a Sunday school for weekend residents close to their homes. The Log Cabin Church now gives its name to the entire area along South Cobb Drive. The Vinings United Methodist Church was located on Paces Mill Road, but the building burned down in the early 1940s. What was salvaged was moved to the empty public school building. The church bought the school building and remains an active part of the community. The Baptist church was discontinued with the development of modern Vinings, and its building now houses a Mexican restaurant and pizza place. Vinings had four African American churches. The largest was Mount Sinai A.M.E, which also served as the "colored" public school, and was located on the side of Vinings Mountain. New Salem was another church in the same area. First St. John's and Second St. John's Churches served the settlement area closer to Atlanta Road. All four churches are now closed; the land became valuable in the new scheme of things. The cemeteries from Mount Sinai and New Salem Churches, of course, still exist but are dependent on civic groups for maintenance. The cemeteries for First and Second St. John's Churches are maintained by a dedicated group of community volunteers.

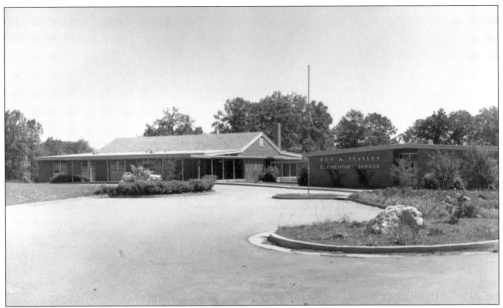

Teasley Elementary School opened in 1963 as a first-through-eighth-grade public school. It was named for Roy Teasley, the first principal of nearby Fitzhugh Lee Elementary School. A portrait of Teasley was dedicated by the school's first principal, W.O. Reece Jr; it still hangs in the school. (Both courtesy of Teasley Elementary School.)

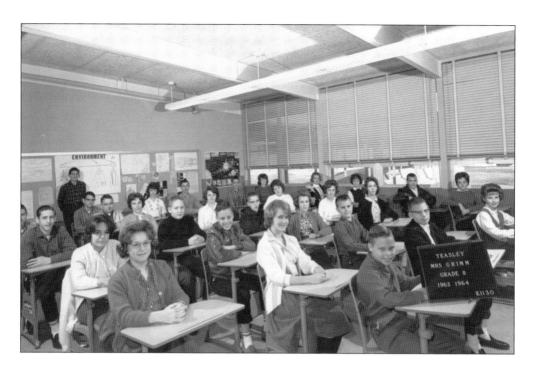

The school opened with two classes for first and second grade, while each of the other grades had one class. The first graduating class of eighth-graders was the only year that the school had an eighth grade. The image below is of one of the two first-grade classes. The school remains one of the highest achieving in the Cobb County School District. (Both courtesy of Teasley Elementary School.)

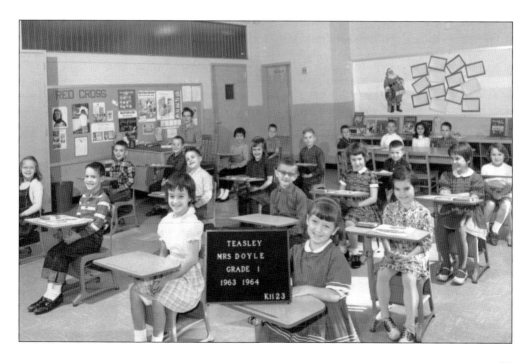

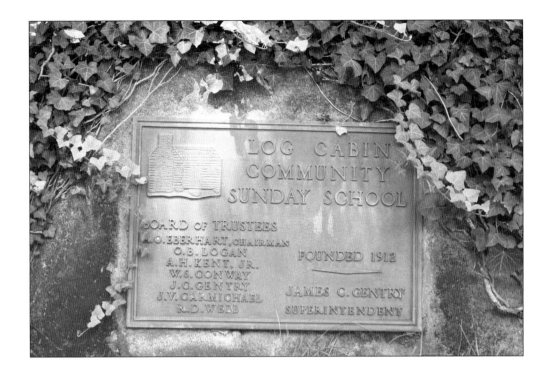

Log Cabin Sunday School was formed as a nondenominational school on June 2, 1912. It served the weekend community from Atlanta who wanted to attend a Sunday school class and then take the trolley to their Atlanta churches. The Sunday school indeed started out as a log cabin. (Both courtesy of the Log Cabin Church.)

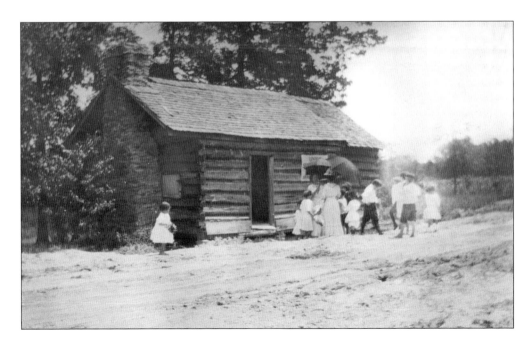

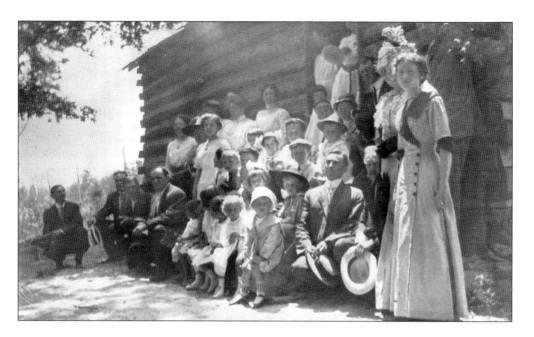

From its beginning in 1912, and upon the building of the new, larger structure in 1919, the Log Cabin Church was a family-friendly place with many children, as is evident in the image above. The opening day had a charter membership of 44. This grew to 140 people who subscribed to the new, larger Log Cabin Sunday School just seven years later. (Both courtesy of the Log Cabin Church.)

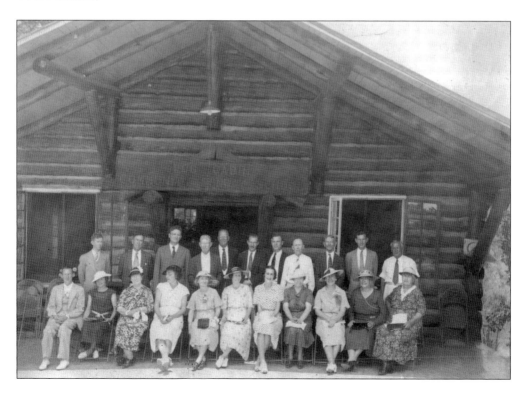

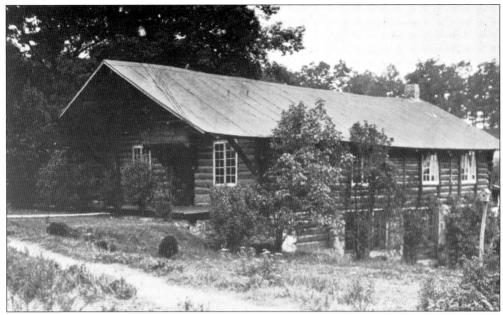

The Log Cabin structure was a Sunday school with a superintendent, and visiting pastors were invited to speak. The congregation continued to grow with the community. Now, Log Cabin Church is still nondenominational and is a popular location for weddings. (Both courtesy of Log Cabin Church.)

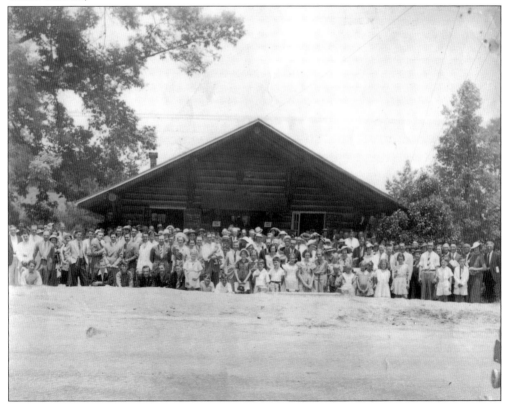

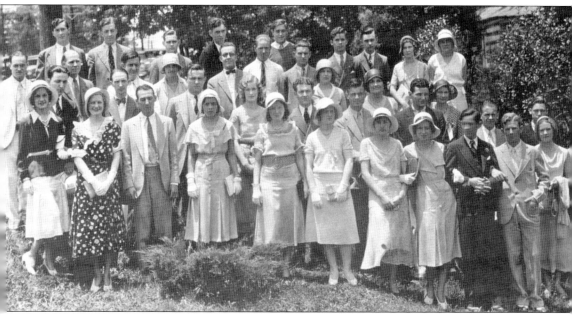

The Young People's Sunday School class of 1932 shows the vibrancy of Log Cabin Sunday School. It was still led by a superintendent and still met in the rebuilt, larger cabin. Rally Day had its own church band of young men and women. According to records, the average attendance during that time was 142, and the collection averaged $14.53. (Courtesy of the Log Cabin Church.)

The new stone chapel was dedicated on December 4, 1949, and was called the John Vinson Carmichael Chapel. It had a new organ in memory of J.H. Carmichael, and both were dedicated by Mrs. J.H. Carmichael. The date served as an anniversary, and in 1950–1951 the program was dedicated to Mr. and Mrs. Roy Teasley, for whom the public elementary school was later named. (Courtesy of Jen Case, photographer.)

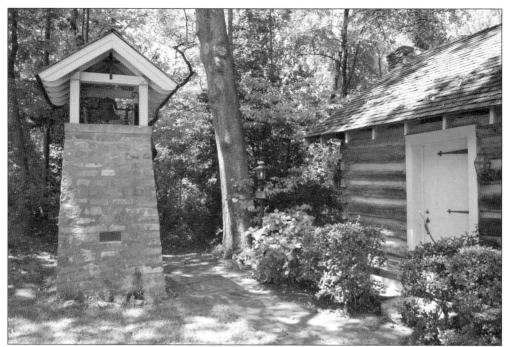

The current stone chapel, with its bright red doors, is next to the original log cabin, built in 1912. The cabin now serves as a museum for the church. On the other side of the current chapel is the World War II Wishing Well, which is dedicated to members who fought during that war. The bell tower stands next to the original log cabin. Both the well and the bell tower are often used for the many weddings that are still performed at the Log Cabin Church. (Both courtesy of Jen Case, photographer.)

Hanging on the wall of the church is the *Friendship Dahlia* quilt made by the Ladies Aid Society in the 1940s. The quilt was meant as a fundraising project but was never raffled off. Found years later in the original log cabin, it was then restored and framed. Minutes from the Ladies Aid Society refer to Gennie Valentine Haralson attending meetings as a child with her mother. Gennie is pictured here (right) with Mariah Thompson at the quilt dedication on April 18, 2010. (Courtesy of the Log Cabin Church.)

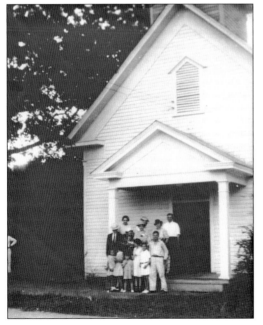

The presence of the Methodist Church in Vinings goes back to the 19th century. It was organized in 1872 in the center of the Hardy Pace Plantation with three members joining. Later, it met in a house near the present Vinings intersection with itinerant ministers and camp meetings. In 1900, a proper church was built, with the basement serving as a community school. (Courtesy of the Vinings United Methodist Church.)

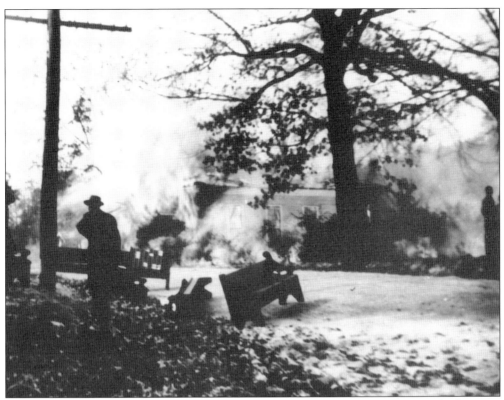

In 1941, the Vinings United Methodist Church burned, and the community worked to save whatever was salvageable. A railroad crew joined the community in rescuing most of the furnishings. The pews, pulpit, and chancel rail were moved into a building once used as the Vinings Public School. The church bought the school twice: first for a nominal sum, and later, after public protest, the building was purchased at a public auction. (Both courtesy of the Vinings United Methodist Church.)

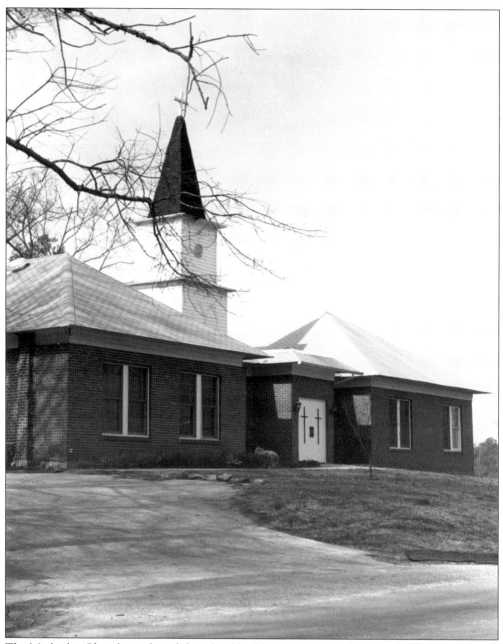

The Methodist Church purchased the school building it was using from the Cobb County Board of Education. In 1953, major improvements started on the old building to serve the church's needs: a steeple was added, the roof replaced, and a heating plant installed, indoor plumbing was put in, and the main sanctuary was redecorated. The original pews were remade and dedicated to the memory of various founding members. (Courtesy of the Vinings United Methodist Church.)

The congregation of the Methodist Church has changed from the 1950s when this congregational photograph was taken, to the 1980s, when the church picnic image was snapped. In 1957, property for the church's parsonage was acquired, and the current building was completed in 1972. At that time, the education wing and air-conditioning were added. (Both courtesy of the Vinings United Methodist Church.)

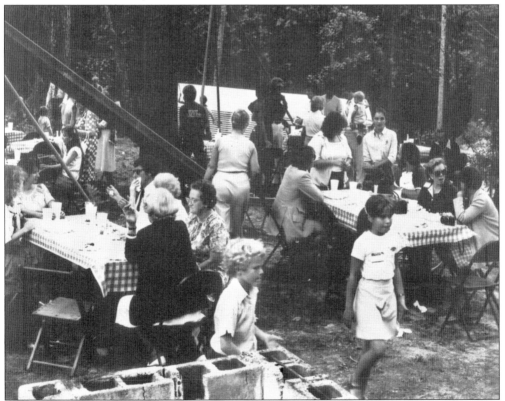

Vinings First Baptist Church is now relocated, but at one time it served the community from its location on New Paces Ferry Road. It was constituted and organized in 1948 and was relocated in the 1980s to South Cobb Drive in Smyrna. The building is now a Mexican restaurant serving the Vinings area. The site was redeveloped by the Vinings Jubilee Company. The large trees that are very evident in this photograph were one of the distinctive features of Vinings. (Courtesy of Mandy Ford Bubel and Robert and Peggy Ahlstrand.)

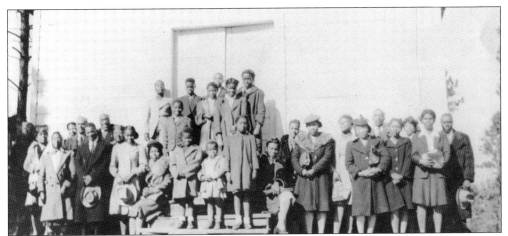

Mount Sinai Baptist Church was on Vinings Mountain. The congregation, pictured here in the 1940s, was one of the largest African American congregations in Vinings. The other church serving the black community was New Salem A.M.E. It was this church that housed the "colored" school, grades one through three with one teacher. The church was discontinued, and the congregation moved to Mableton. The property was sold, and a high-rise office building was constructed; however, the cemetery remains on the slope of the mountain. (Courtesy of Walter Conley.)

Mount Sinai Baptist Church was served by Rev. Mance Mapp and his brother. They led the congregation in restoring and growing the church and enjoyed the support of the community. Wooden pews were bought for the church in the 1940s, and Earle Carter Smith donated a large antique church bell. Money for the restoration was raised through barbecues and fish fries. During the restoration, the size of the congregation went from nine members to around 50, and services were held weekly rather than just the first and third Sundays of the month. The interior of Mount Sinai features special seating for the church's deacons. Here, Willie North (right) sits as church deacon along with an unidentified friend. (Courtesy of Walter North.)

The Mount Sinai and New Salem Cemetery is located on a steep hillside below the location of the two churches. The Boy Scouts originally took up the project of maintaining the cemetery but found it was a very big project; the Vinings Rotary Club joined them in maintaining the cemeteries. There are two sections to the graveyard. At one time, there was a stream from the Vinings spring that flowed down the hillside, which was used in church baptisms. Now, the stream is piped under Paces Ferry Road. (Courtesy of Ross Henderson Photography.)

Willie "Uncle Jack" North was a church deacon and a well-known member of the community. He moved to Vinings in 1936 from Carroll County and built what he described as "a good size house, but it wasn't up to today." The African American community he remembered consisted of about 100 residents and supported its own fraternal lodge, dancing hall, and school. His marker is prominent in the cemetery, just as he was in life. (Courtesy of Ross Henderson Photography.)

This cemetery served Mount Sinai and New Salem Churches. Common-style grave markers are found in the Mount Sinai and New Salem Cemetery and the St. John's Cemetery. The smaller centerpieces of the marker were bought from the funeral home along with the mold for the concrete backing. The family could then make their own marker. (Both courtesy of Ross Henderson Photography.)

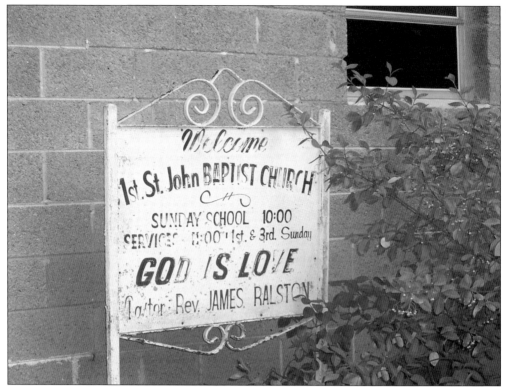

First St. John's and Second St. John's had members from the black community who lived in the Settlement part of Vinings, close to Log Cabin. The churches were served by a circuit preacher. Both were discontinued, fell into disrepair, and were demolished. The area is now scheduled for redevelopment. (Both courtesy of Roberta Cook.)

The disrepair of the First St. John's structure eventually led to its being discontinued and abandoned. These interior shots provide an idea about the sanctuary. The building became a hazard and was completely demolished. The church graveyard is maintained by the River Line Historic Preservation Society. (Both courtesy of Roberta Cook.)

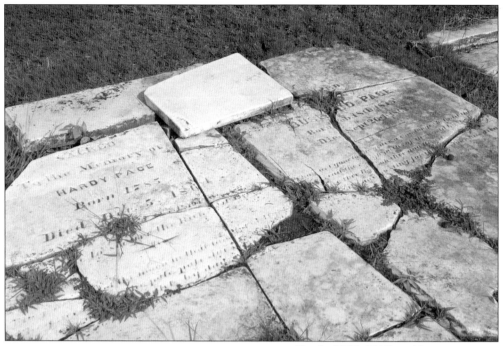

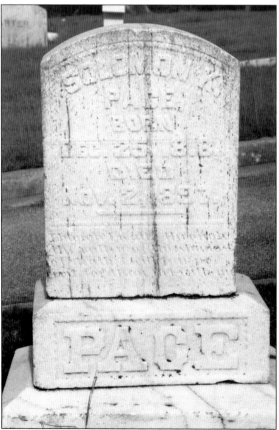

Hardy (1785–1864) and Lucy (1786–1842) Pace and their son Bushrod (1819–1862) are among the earliest graves in Vinings. They are flat markers on the top of Vinings Mountain. The markers were weatherbeaten or vandalized and later put back in order. As the family had more money after Reconstruction, upright markers, such as the one for Solomon Pace, were used. (Both courtesy of Ross Henderson Photography.)

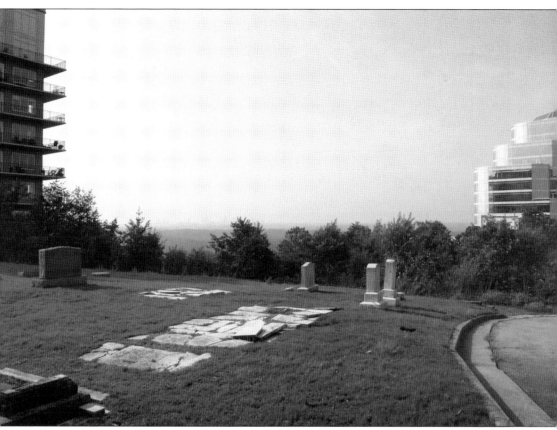

The Pace Cemetery is still an active one, surrounded by modern Vinings. It still has an overlook of Atlanta that attracted General Sherman and his troops so long ago. The view now is illustrative of the old and new that makes the area unique. (Courtesy of Ross Henderson Photography.)

The Pace Cemetery reads like a history of the community. It holds the remains of the Pace, Carter, Randall, Maurer, McAfee, Robinson, Wilke, and Yarbrough families. The cemetery is private, with limited access due to evident vandalism. (Courtesy of Ross Henderson Photography.)

Eight

NELLIE MAE ROWE

Folk artist Nellie Mae Rowe is one of Vinings best-known figures. Her little house of just three rooms was west of the railroad on Paces Ferry Road. It became known as Nellie's Playhouse.

A longtime resident of Vinings, Nellie Mae was born in 1900 in Fayetteville, Georgia. When married at age 16, she followed her first husband, Ben Wheat, to Vinings. After he died, she married Henry "Buddy" Rowe in the early 1930s. Buddy had children from his first marriage who did not want their young stepmother in the established house, so he built a small house for just the two of them that became the Playhouse. As with most of the African American women of the area, she worked as a domestic until her husband died. With widowhood, she was independent and childless and began to explore her creative nature. She invited visitors into the house and yard, where her dolls and chewing-gum sculptures were displayed.

Her art was comprised of simple materials, crayons, recyclables, and chewing gum—which she herself had chewed. Much of her work reflected her own self-image, along with African and Caribbean symbolism. Her brightly colored drawings and sculptures hang now at the High Museum in Atlanta, the Smithsonian American Art Museum in Washington, DC, and the American Folk Art Museum in New York City, along with other major institutions.

Nellie Mae Rowe died in 1982 and was buried in Fayetteville, Georgia. There is a book on her life and work, *The Art of Nellie Mae Rowe: Ninety-Nine and a Half Won't Do* by Lee Kogan, as well as a short documentary filmed in the 1970s called *Nellie's Playhouse* by Linda Armstrong (available on YouTube.com).

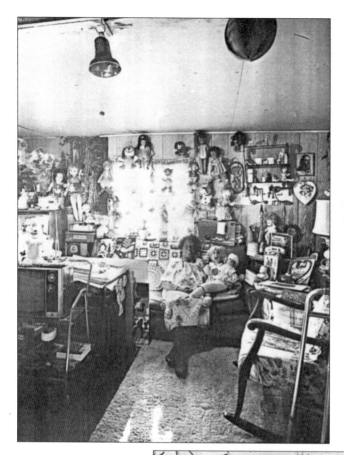

Nellie Mae's Playhouse was open to visitors who signed her guest book. She would entertain people by singing hymns while playing on her electric organ. Her dolls featured different wigs and glasses. Some were made to look like different people, but most reflected her image of herself. These were placed around her house and yard to keep her company. (Courtesy of the Vinings Historical Preservation Society.)

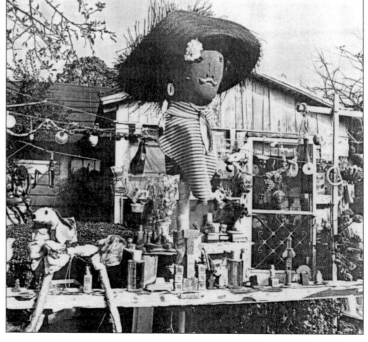

Nellie Mae Rowe was born in Fayette County and learned crafting from her father's basket making and her mother's quilting. She learned to work on the farm and married at 16. Nellie Mae moved with her husband to Vinings, where she worked as a domestic. Her art reflected the vibrancy of life. Her vivid colors and her subjects, such as birds and dogs, let the public feel her affinity for all living things. (Courtesy of the Vinings Historical Preservation Society.)

The yard was on Paces Ferry Road and did not conform to community standards as viewed by passing traffic. Nellie Mae was thought to be a conjurer, and children were often told to cross the street rather than be in that dangerous environment. Community fear turned into curiosity, and she welcomed visitors into her yard and home and even had a guest book for them to sign. (Both courtesy of Robert and Peggy Ahlstrand.)

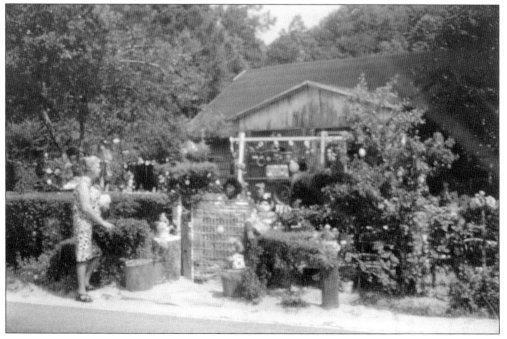

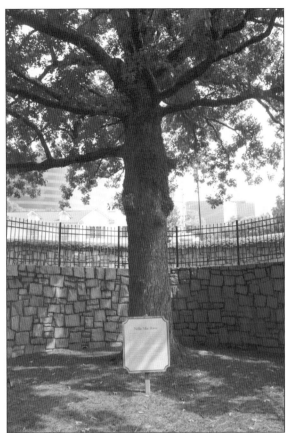

The stone wall and the historical marker indicate the location of Nellie Mae Rowe's house just west of the railroad on Paces Ferry. This was part of the Vinings Mountain community, close to the Mount Sinai and New Salem Cemeteries. (Courtesy of Ross Henderson Photography.)

The folk art of Nellie Mae Rowe hangs in museums in New York, Pittsburgh, and Atlanta. The art sells for thousands dollars, and some people are lucky enough to have pieces in their private collections. (Courtesy of Ross Henderson Photography.)

Nine

A WONDERFUL PLACE TO LIVE

After World War II, Atlanta was growing, and the outlying areas were growing too. Passenger train service was gone, along with trolley service, but there was the family car. Families were buying property on Stillhouse Road, and the Hill family property was sold and became the Cochise subdivision. Earle Carter Smith was involved in community and county affairs, and Vinings developed a sense of community.

The Vinings Homeowners Association was formed to protect property values. Civic clubs such as the Vinings Rotary and the Vinings Village Civic Club were formed. The roads were paved, and the Vinings Pavilion was purchased by Mrs. Smith, who made it an antique shop. Co-Co Nut Antiques and the Antique Shop of Vinings, along with other dwellings converted to shops, joined Vinings's commercial life. Vinings became a site for bus tours and ladies' luncheons. Ruth Vanneman and Franklin M. Garrett, historian with the Atlanta Historical Society, led groups such as the Georgia Tech Faculty Wives Club on historical tours.

The history of the area was captured by the Vinings Village Woman's Club in its masterpiece quilt. The 20 quilt squares depict historical events or landmarks in Vinings. This project, initially designed to encourage friendship amongst the quilters, was used to promote pride and a sense of unity within the community.

The area, known for its shady oak trees and modest white frame houses, started to change as people discovered the value of living in close proximity to the city of Atlanta with its interstate road system but with the somewhat lower Cobb County tax structure and excellent county services. Ruth Carter Vanneman owned some of the large pieces of land in Vinings and used the sale of the land to lead its growth.

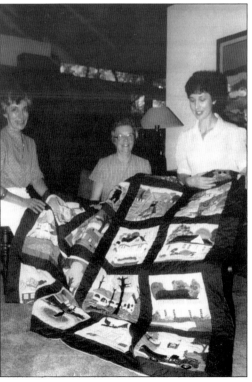

Fifteen ladies within the Vinings Village Woman's Club undertook a project to record the unique history of the Vinings community. Twenty events or landmarks were chosen for the quilt, the images were creatively interpreted into quilt patterns, and each seamstress chose her fabrics and decorative detail. The work was constructed at home and took four years to complete. By the summer of 1982, the final quilting of the squares was done by Catherine Culver and Ruth Erwin. The 15 ladies seen above found a way of preserving history through a traditional American art form. Pictured at left are, from left to right, Peggy Ahlstrand, Culver and Erwin. (Both courtesy of Robert and Peggy Ahlstrand.)

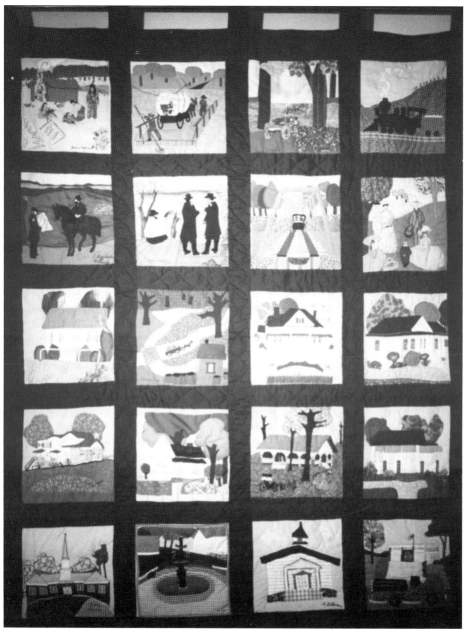

The squares of the Vinings quilt represent different years and events in Vinings history. The squares start with the Cherokees along the Chattahoochee before the land lottery in northern Georgia. It continues through the Civil War and different structures of the 19th century. Some of the latest buildings represented are the Vinings Fire Station of 1960 and the Earle Carter Smith Memorial Fountain, dedicated in 1977. The finished quilt was intended to be raffled as a Woman's Club fundraiser. When the piece was finished, the club decided to preserve it as a historical record. The finished quilt was offered to the Atlanta History Center until a suitable public place in Vinings could be found. In 1990, the Cobb County Public Library System built a branch library in Vinings where the quilt now resides in a specially constructed display case designed by Robert Ahlstrand. (Courtesy of Robert and Peggy Ahlstrand.)

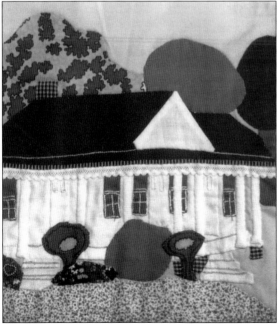

The quilters chose the Vinings sites and events that were to be shown. A photograph or sketch was used as an illustration to create a pattern. The individual creating the square would select her own materials and stitches to bring the image to life. (Both courtesy of Robert and Peggy Ahlstrand.)

Robinson's Tropical Paradise was a fixture along the Chattahoochee River. Virgil "Jake" Robinson Jr. started a chicken stand, Robinson's Chicken, which sold a plate for $1.25. Jake purchased the Payne property, and the chicken stand expanded over time into Robinson's Tropical Gardens, which was built in 1945. After the roadhouse-style nightclub burned several times, bricks left from the Rose distillery were used in its reconstruction. During the 1960s and 1970s, the building was used for proms and fraternity formals. Robinson's closed its doors in 1973 and reopened with different owners in 1995. It is now Canoe Restaurant, with a lovely river setting, and is well known throughout the Atlanta metropolitan area for its fine food and service. (Both courtesy of the Canoe Restaurant.)

During the late 1960s and early 1970s, Atlanta was a university town that attracted a large college-aged population. One of the leading pop/rock radio stations was KQXI. During the summer, the station sponsored a river raft race around the area where I-285 crosses the Chattahoochee River and extends southward toward Vinings. Eventually, the river race was phased out due to excessive alcohol use and water pollution. (Both courtesy of the Vinings Historic Preservation Society.)

There is a pretty French fountain at the intersection where Paces Ferry and Paces Mill Roads meet. The fountain marks the center of Vinings and was selected by Libby Eubank and B.J. Boyes for the Vinings Village Civic Club. It is dedicated to the memory of Earle Carter Smith. The plantings surrounding the fountain are still maintained by members of the Vinings Village Civic Club. (Courtesy of the Vinings Village Woman's Club.)

One of the long-gone establishments of the 1970s is the Majik Market next to the fire station on Paces Ferry Road. Previously, in the 1960s, there was a store known as Pot O'Gold, which was described by Jody Smith for the *Vinings Gazette* as "the rundown filling station with old appliances in the yard." (Courtesy of the Vinings Historic Preservation Society.)

The large oaks provided the beautiful shady areas for which old Vinings was known. This large oak was located near the center of the community across from the Old Vinings Inn. Age and development damage took their toll, and although present-day Vinings has lovely trees, this one, dwarfing Peggy Ahlstrand, and others are now gone. (Courtesy of Robert and Peggy Ahlstrand.)

Craft and art fairs were an annual part of Vinings life. The traditional Fall Antique Fair was sponsored by the Daughters of the American Revolution around the original pavilion location. It was just one part of the Fall Festival. (Courtesy of Mandy Ford Bubel.)

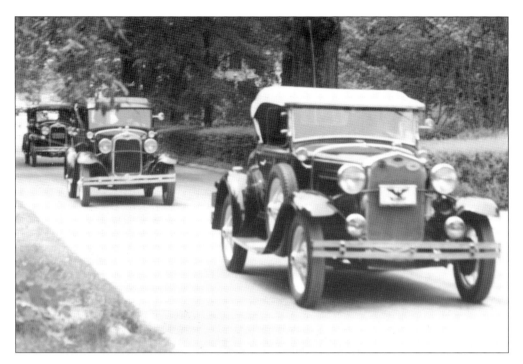

Antiques were a special part of mid-century Vinings. The Vinings Civic Club used an antique auto show and parade as a fundraiser. People could just imagine the history of Vinings at the turn of the century with Atlanta residents motoring out to spend the afternoon picnicking and dancing at the pavilion. (Both courtesy of Mandy Ford Bubel.)

Vinings remained residential—a nice family place to live. Dad would get on Interstate 75 to go to work in Atlanta, mom would have her lady friends and civic projects with the Vinings Women's Club, and the kids could have fun with each other. (Courtesy of Mandy Ford Bubel.)

Winters are short and not too extreme. Snow and ice do present a travel problem in Vinings due to the inclines and slopes of the area. There was no removal equipment in the past, but after a few hours the sun would come out and make travel possible again. (Courtesy of Mandy Ford Bubel.)

The Vinings Polo Club was founded in 1984 by Mr. and Mrs. Dolph Orthwein on property along the Chattahoochee River. Orthwein Field is home to the Vinings Polo Club; it is used by other clubs and has instructional classes. (Courtesy of Dolph and Judy Orthwein.)

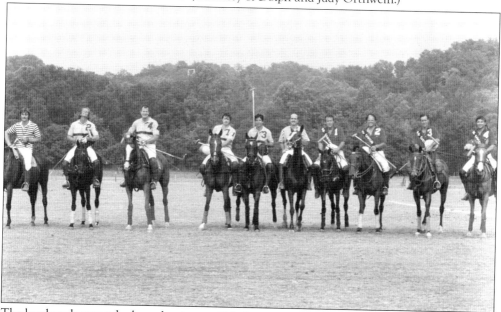

The lovely polo grounds along the river on Polo Lane give Vinings its ambiance of gracious living. The houses around it are built on higher ground and have a view of the polo field and its games. (Courtesy of Dolph and Judy Orthwein.)

Francis Cole, Jackie Pawli, and Ellen Old were co-owners of the Village Clothes Horse in the mid-1960s and of the Village Sample Shop. The Village Sample Shop resold women's merchandise from the Atlanta Merchandise Mart. Its customers came from Vinings, Atlanta, and Smyrna to take advantage of new sample fashions. The store also supplied the clothing that was modeled at the Vinings Tea Room during ladies' luncheons. (Both courtesy of Karen Cole Turner.)

In the 1960s, Camp Bert Adams provided Scout fun for a week of boating, canoeing, archery, nature study, craft, and swimming for $18.50. The camp had a trading post, Adirondack shelters, a nature lodge, and other buildings. Boys from the Atlanta area would arrive at Vinings by train or bus and walk up Mount Wilkinson for a week of troop camping. (Both courtesy Georgia State University Library Special Collections and Archives.)

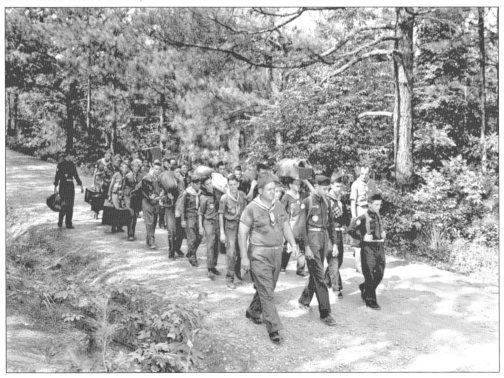

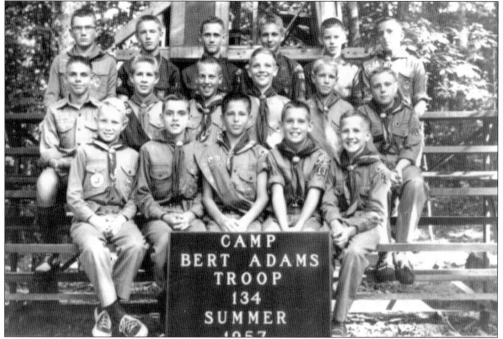

The boys of Troop 134 at Camp Bert Adams in the summer of 1957 were there to enjoy life out of the city. The article about camping from the *Atlanta Area Council Scouter* in 1960 stated, "The staff of Camp Bert Adams . . . are doing an excellent job of helping our Scouts grow in Scout skills and Scout spirit, and are due a vote of thanks from all of us." (Courtesy of Georgia State University Library Special Collections and Archives.)

The Boy Scout lodge at Log Cabin Church belongs to Boy Scout Troop No. 1. It was one of the first troops in the Atlanta area and is one of the longest-lasting troops in Georgia. (Courtesy of Jen Case, photographer.)

Ten

DEVELOPMENT AND PRESERVATION

The gentile life of suburban Vinings began to give way to expansion in the 1980s, as developers were interested in land close to Atlanta. Vinings offered the lower taxes of Cobb County and something extra. That extra was a community with a strong sense of belonging and commitment. Land was sold to speculators and then to developers. Ruth Vanneman sold land for the Vinings Jubilee shopping area to Felix Cochran. The Vinings Homeowners Association, the Vinings Civic Club, and eventually the Vinings Woman's Club raised money to save the Vinings Pavilion and move it to a site next to the Pace House owned by the Vinings Historic Preservation Society.

This sense of commitment by civic clubs makes Vinings a place with a strong sense of identity. Surrounding subdivisions and areas all put the word "Vinings" into their names. The community is now mixture of corporate offices, upscale restaurants, and shopping and is a sought-after residential area.

Willie "Uncle Jack" North lived and worked in Vinings. After retiring from the railroad, he was a handyman and gardener who lived in the community wedged between Camp Bert Adams and Paces Ferry Road. Land speculators began buying up property from homeowners like Willie and from the two African American churches: Mount Sinai Baptist and New Salem A.M.E. New Salem used the profits from the land sale to build a new church in Mableton. Many landowners had homemade property titles, and although the families had occupied sites for generations, the titles had been handled very informally. (Courtesy of the Vinings Historic Preservation Society.)

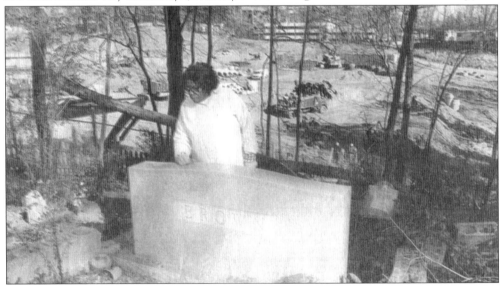

The New Salem and Mount Sinai Cemetery on Paces Ferry Road holds many members of Vinings's African American community. The relatives of Annie Conley (pictured) are buried there. Development surrounded the cemetery as landowners sold their property, but the cemetery still exists, honoring what remains of that humble community. (Courtesy of the Vinings Historic Preservation Society.)

Ruth Vanneman sold several acres of property on Paces Ferry Road to developer Felix Cochran, who created upscale shopping. Vinings Jubilee was dedicated on October 22, 1986. It has a mixture of shops and restaurants with white cottage facades in keeping with the existing architecture. (Courtesy of Vinings Jubilee.)

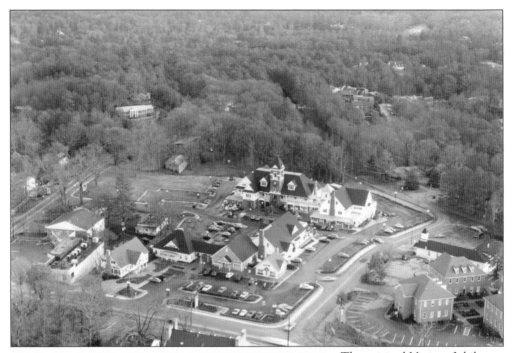

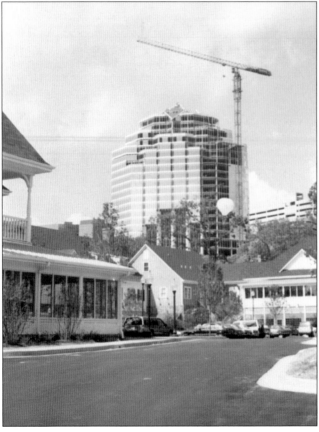

The original Vinings Jubilee was smaller than it is now. The Overlook Office Complex replaced Camp Bert Adams and brought in workers looking for housing, dining, and entertainment in a safe, friendly, walkable environment. (Both courtesy of Vinings Jubilee.)

The DAR Cherokee Chapter Antique Fair continued as the Fall and Spring Festival with Vinings Jubilee as one of the sponsors along with the Vinings Rotary Club and the Vinings Village Woman's Club. (Courtesy of Vinings Jubilee.)

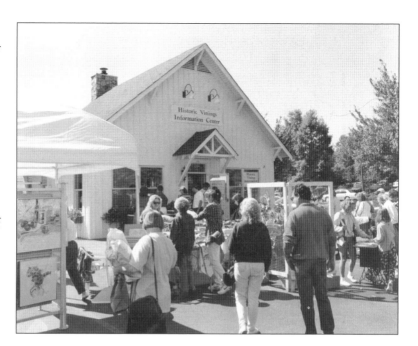

When Ruth Vanneman passed away in 1994, her estate was auctioned as a part of the 28th annual Vinings Fall Festival. There was much excitement, as the historical possessions of Hardy Pace's progeny were made available to the public. The estate auction was held in October on the grounds of the Carter home. Items included period furniture, European china, framed paintings, and Persian rugs. Three thousand people attended, with the estate raising $80,000 through the auction. Ruth's will stipulated that her house was to be destroyed and the property sold. (Courtesy of Joanne Newman.)

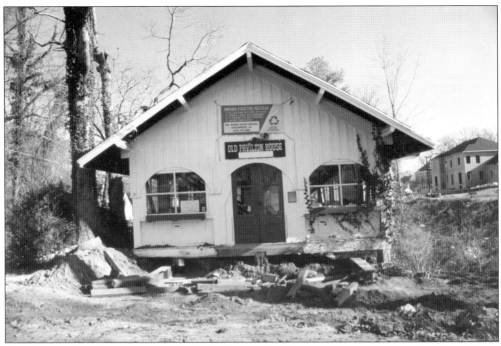

The Vinings Pavilion was originally built close to the Vinings train station north of Paces Ferry Road in 1874. It was an open-air structure until it was purchased by Hardy Pace's great-great-granddaughter Earle Carter Smith in the mid-1940s. She used it to house antique shops until her death. In the winter of 1996, the entire structure was moved to its Paces Mill Road location. (Both courtesy of Robert and Peggy Ahlstrand.)

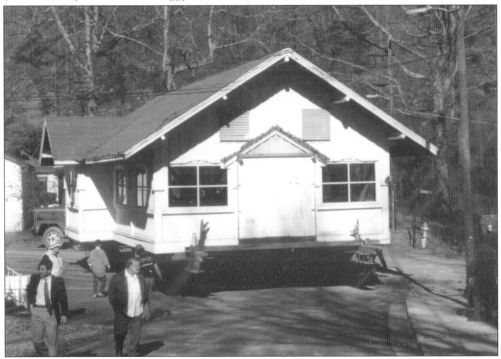

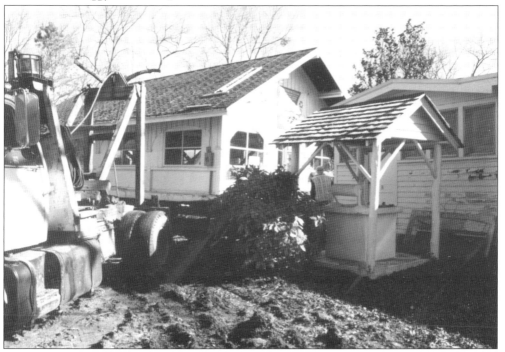

The Vinings civic groups and other benevolent societies raised money to move the pavilion to a site on the grounds of the Pace House on Paces Mill Road. Art festivals were held along with other fundraising activities. The move was successful, and the Vinings Pavilion and the Pace House, with the added catering kitchen and wishing well, make up the historic center of Vinings. (Both courtesy of Robert and Peggy Ahlstrand.)

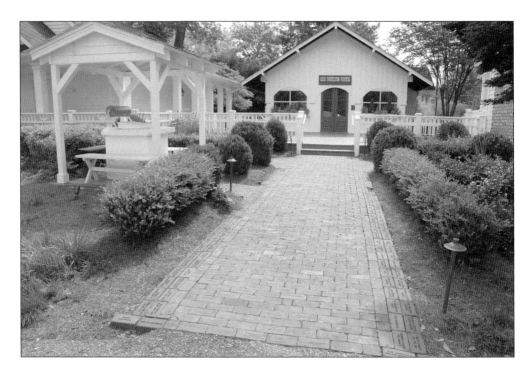

The Vinings Pavilion and the Pace House now sit on one acre of land in the heart of Vinings. The wishing well and catering kitchen finish off the area. Commemorative bricks were sold by the Vinings Historical Preservation Society to help meet the cost of turning this historical area of Vinings into a usable entertainment facility. (Both courtesy of Ross Henderson Photography.)

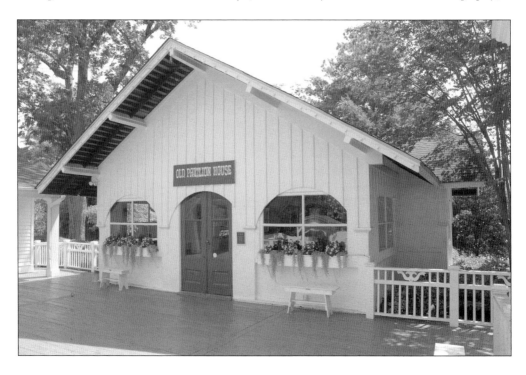

The Pace House was preserved as a museum. There is a foundation devoted to its preservation along with one acre of property. On that acre is the Vinings Pavilion. The house has been restored with furnishings from the mid-19th century and includes a writing desk that was an original possession of Hardy Pace. It is now available as a site for parties, weddings, and other social events. (Courtesy of Ross Henderson Photography.)

The pavilion played a role in the history not only of Vinings but of the entire Atlanta region. As the Carter sisters were trying to keep up the structure and to preserve it for posterity, they asked others for support. One of the organizations offering assistance for the pavilion's upkeep was the Atlanta Chapter of the United Daughters of the Confederacy. Its contribution was acknowledged with a plaque in 1983. (Courtesy of Ross Henderson Photography.)

THE PAVILION

Built in 1874 by the
Western & Atlantic Railroad
Presented By
Atlanta Chapter No. 18
United Daughters
of the Confederacy

October 1, 1983

Paces Ferry Road is an old thoroughfare that at one time linked Cobb County with Buckhead, formerly known as Irbyville. The original Paces Ferry Road connected with what was the Old Decature Road to Cheshire Bridge Road and on to Clifton Road around Emory University. The original link was, of course, Paces Ferry. In 1904, a wooden bridge was built close to that spot. In the early 1970s, the bridge was replaced by a concrete highway bridge. The wooden bridge, now used by pedestrians, helps Lovett School students cross the Chattahoochee River to school. (Courtesy of Ross Henderson Photography.)

The Log Cabin stop of the trolley line going from Atlanta to Marietta has been turned into a county pocket park. Landscaping with roses and crepe myrtle trees has made this location popular with weekend athletes and with residents from the housing units that are now found in the area. (Courtesy of Jen Case, photographer.)

In 1978, the Vinings Village Woman's Club was formed. One of its first projects that year was to have Prof. Fred Gerlach of the University of Georgia School of Environmental Design draw up beautification plans for Vinings. These members and family are following the plans for planting just north of the Chattahoochee Bridge. (Courtesy of the Vinings Woman's Club.)

Another early community improvement project of the Vinings Village Woman's Club was a neighborhood street-sign project. In the 1980s, the club raised $14,500 needed to install 70 street signs with the name "Vinings" included. (Courtesy of the Vinings Woman's Club.)

Art and antique shows have had a place in Vinings for many years and were called the Fall and Spring Festivals. The shows were originally sponsored by the Daughters of the American Revolution, but later other civic sponsors were found. The antique shows have been held at the pavilion and other central locations. This art show was sponsored by the Vinings Woman's Club in 1990 at the home of Ruth Carter Vanneman. The location alone drew many attendees. (Courtesy of Joanne Newman.)

Active, long-standing civic groups are one of the ways in which Vinings distinguishes itself. These groups sponsor regular neighborhood cleanups, raise money for local improvements, and make Vinings the desirable place to live and work that it is today. In 1990, Cobb County built a library in the community, and the Vinings Rotary Club donated and planted the landscaping. (Courtesy of the Vinings Rotary Club.)

Teasley elementary School is the only public school in Vinings, and the Vinings Woman's Club raised money for wall murals to decorate the school as well as other improvements. (Courtesy of the Vinings Woman's Club.)

Vinings, in close proximity to the Chattahoochee River, has areas prone to flooding, as do other riverfront areas in Atlanta. The flood of 1994 affected the Cochise subdivision. The Vinings Civic Club collected cleaning supplies as well as food and water for those impacted in the Atlanta area and then distributed them through the Salvation Army. (Courtesy of the Vinings Civic Club.)

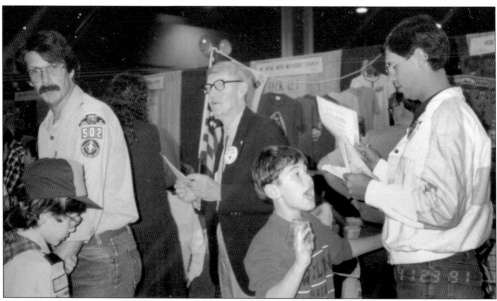

The Vinings Rotary Club has a tradition of helping with Scouting, especially the Boy Scouts. In 1991, the club judged the Scout Show for the Atlanta area. The rotary is also involved with the Scouts in maintaining the Mount Sinai and New Salem Cemetery on Mount Wilkinson. (Courtesy of the Vinings Rotary Club.)

Vinings is a community; it has never been incorporated. The marker placed by the Vinings Civic Association makes it very clear that the Vinings community has its own history, culture, and pride. (Courtesy of Ross Henderson Photography.)

DISCOVER THOUSANDS OF LOCAL HISTORY BOOKS
FEATURING MILLIONS OF VINTAGE IMAGES

Arcadia Publishing, the leading local history publisher in the United States, is committed to making history accessible and meaningful through publishing books that celebrate and preserve the heritage of America's people and places.

Find more books like this at
www.arcadiapublishing.com

Search for your hometown history, your old stomping grounds, and even your favorite sports team.

Consistent with our mission to preserve history on a local level, this book was printed in South Carolina on American-made paper and manufactured entirely in the United States. Products carrying the accredited Forest Stewardship Council (FSC) label are printed on 100 percent FSC-certified paper.